Northwest
Wild

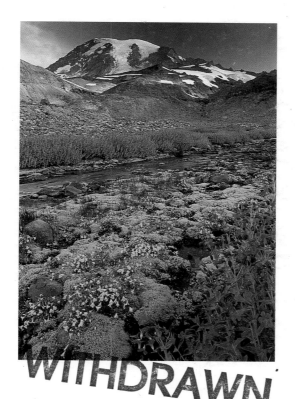

WITHDRAWN

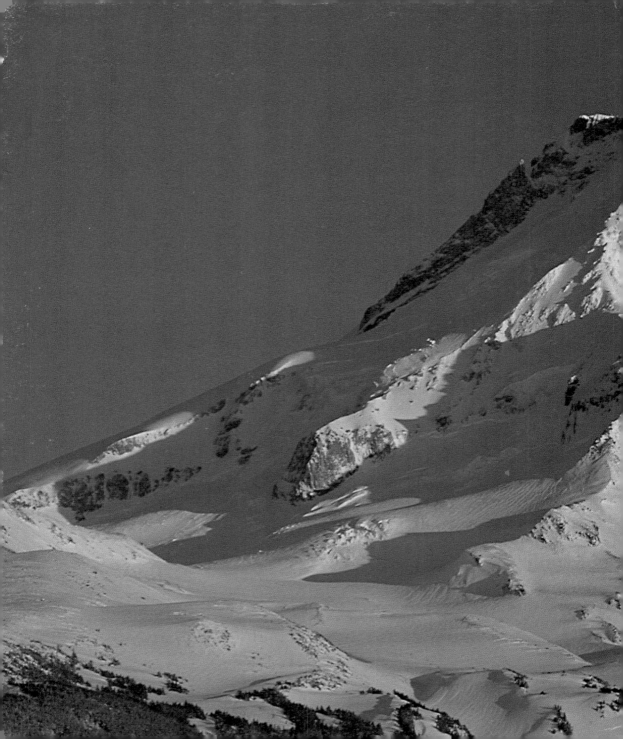

Northwest
Wild

Celebrating Our Natural Heritage

ART WOLFE

SASQUATCH BOOKS
SEATTLE

Special thanks to all my friends, with whom
discovering the beautiful Northwest has been such
a pleasure over the years

Photographs ©2004 by Art Wolfe

Printed in Hong Kong
Published by Sasquatch Books
Distributed by Publishers Group West
10 09 08 07 06 05 04 6 5 4 3 2 1

Book design: Kate Basart
Interior layout: Stewart A. Williams

Frontispiece: Mt. Rainier and alpine stream at sunrise, Mt. Rainier National Park, Washington.
Title page photo: Mt. Hood, Mt. Hood Wilderness Area, Oregon.

Join the 300,000 members of National Parks Conservation Association and help preserve all of our nation's
beloved parks at www.npca.org or by calling 1-800-628-7275.

Library of Congress Cataloging-in-Publication Data is available.

ISBN 1-57061-404-0

Sasquatch Books
119 South Main Street, Suite 400
Seattle, WA 98104
206/467-4300
www.sasquatchbooks.com
custserv@sasquatchbooks.com

{introduction}

The wild places of the Pacific Northwest can bring out the photographer in all of us. After visiting Olympic National Park's mossy rain forest trails and Mt. Rainier National Park's panoramic wildflower meadows, we eagerly pour over dozens of snapshots. If you're like me, your photos are invariably overexposed and barely resemble the places and moments remembered so clearly. Luckily, we have Art Wolfe to remind us of the exhilarating and peaceful moments we left behind.

It is no surprise that Art Wolfe's artistry in *Northwest Wild* is inspired by the region's national parks and wilderness areas. Even if you've never been to the Pacific Northwest, you can see that it's home to some of the most beautiful and ecologically diverse places on Earth.

Today, however, America's national and local parks face greater challenges than ever before. Government provides less than two-thirds of needed funding to protect wildlife and cultural artifacts, repair crumbling bridges, research archaeological sites, and teach our children about the wonders of the outdoors—and our shared history. Fewer and fewer wild salmon return each year to spawn in Olympic National Park where more than twenty species, including bears and eagles, wait with hungry stomachs. Development has isolated Mt. Rainier, turning this iconic park into an island.

Since 1919, the nonpartisan National Parks Conservation Association (NPCA) has been the only citizen's advocacy organization dedicated to protecting America's national parks. In the Pacific Northwest, the NPCA is developing solutions to the growth pressures squeezing Mt. Rainier and is restoring wild salmon in the Olympic wilderness.

By protecting our wilderness, we protect our natural and cultural heritage, and guarantee our children the same exhilarating memories of the Pacific Northwest that are captured on film today.

Heather Weiner
Northwest Regional Director
National Parks Conservation Association

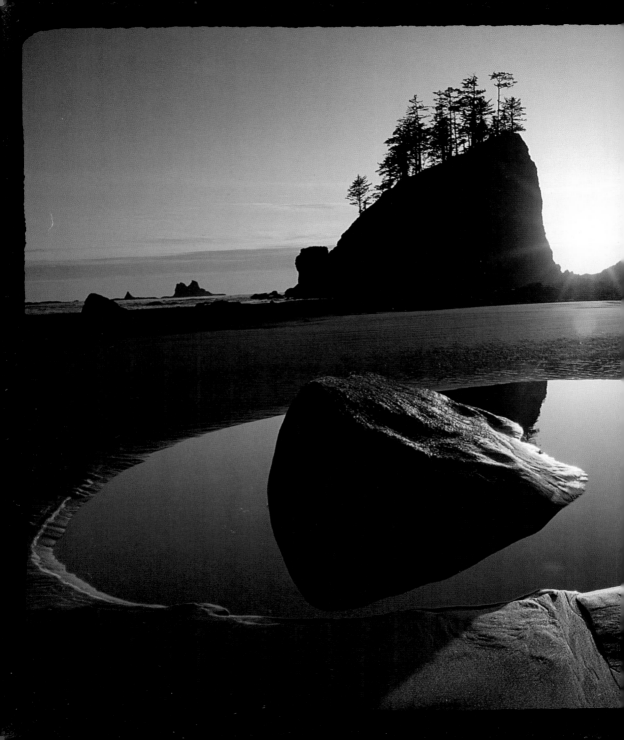

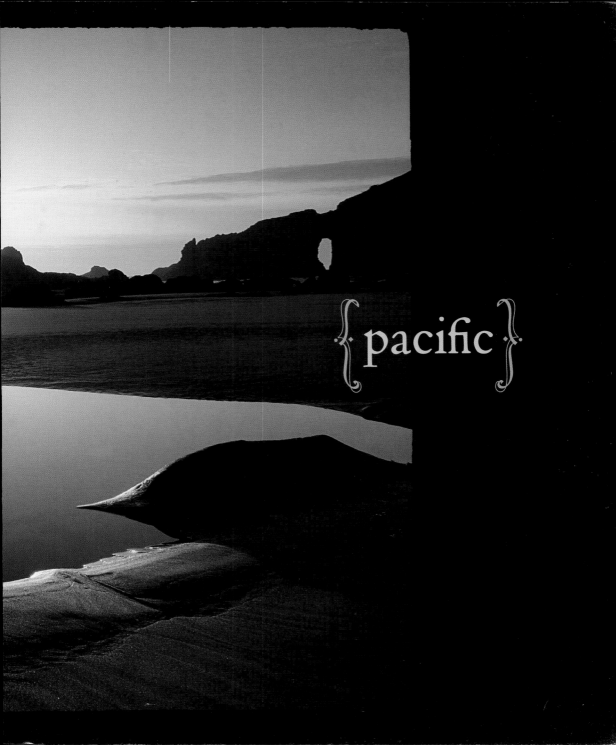

{pacific}

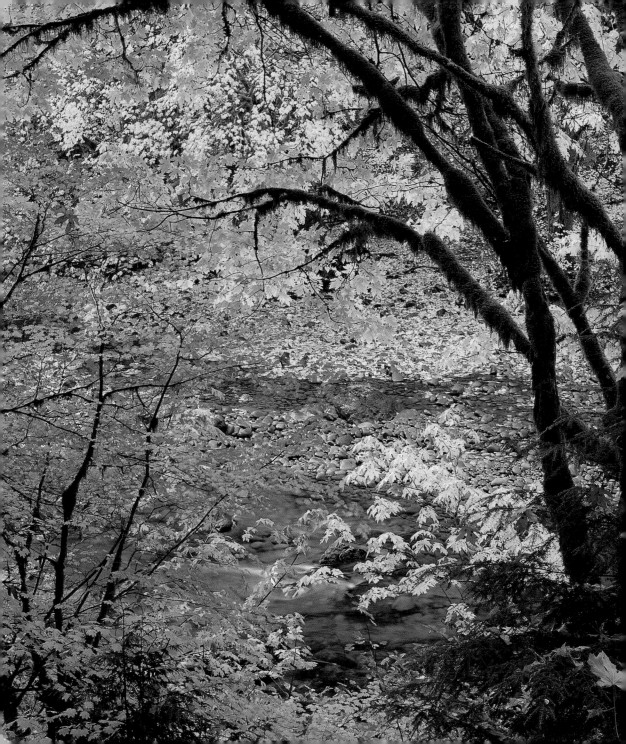

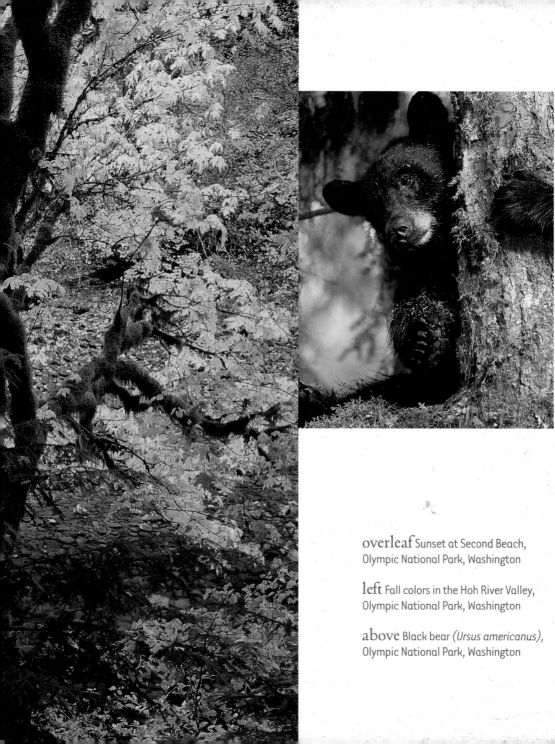

overleaf Sunset at Second Beach,
Olympic National Park, Washington

left Fall colors in the Hoh River Valley,
Olympic National Park, Washington

above Black bear (*Ursus americanus*),
Olympic National Park, Washington

3

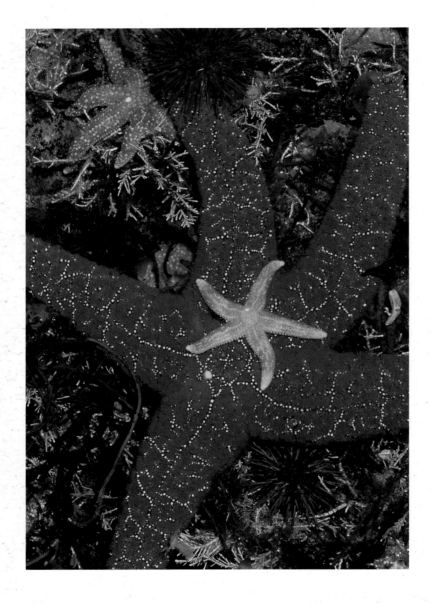

left Ochre sea star, blood star, and purple sea urchin, San Juan Islands, Washington

right Rabbit tracks and dune grass, Oregon Dunes National Recreation Area, Oregon

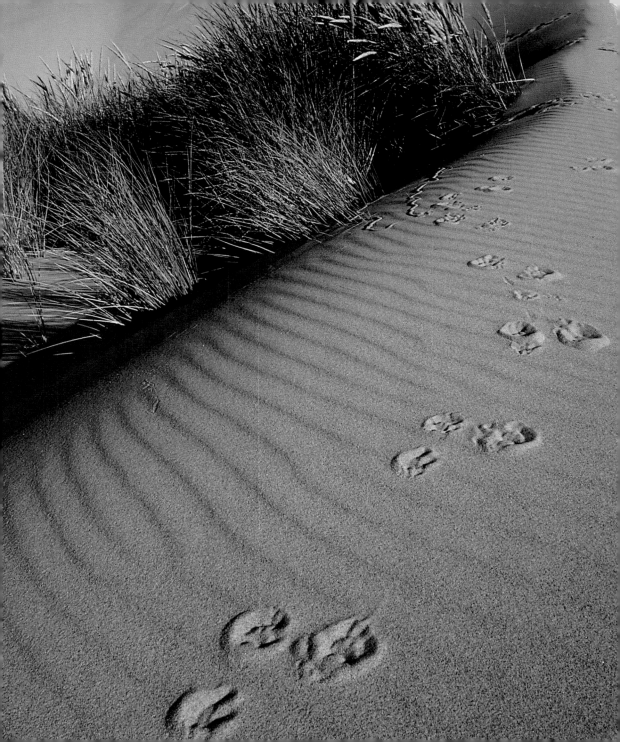

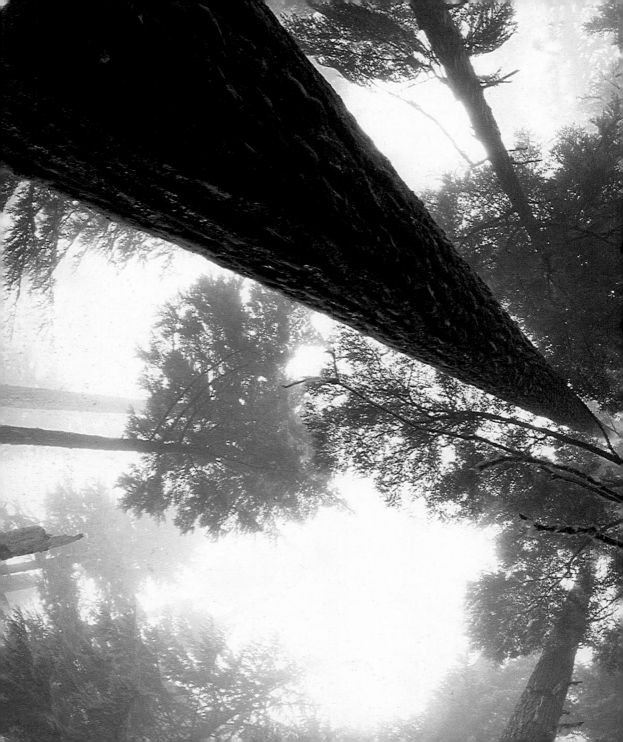

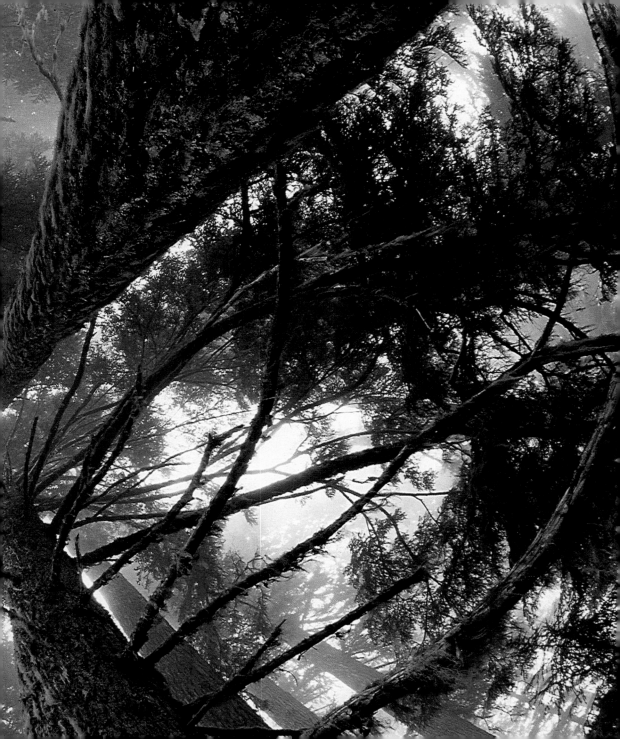

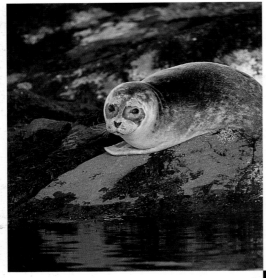

overleaf Old growth forest, Olympic National Park, Washington

left Harbor seal (*Phoca vitulina*), San Juan Islands, Washington

below Deer fern fiddlehead (*Blechnum spicant*), Olympic National Park, Washington

right Bald eagles and eaglets (*Haliaeetus leucocephalus*), Orcas Island, Washington

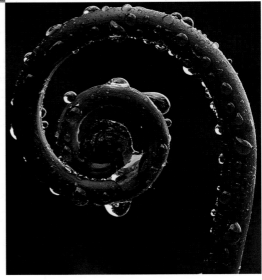

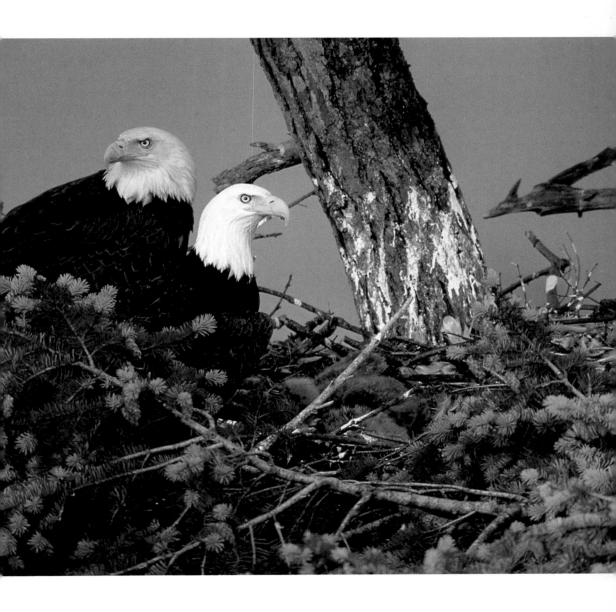

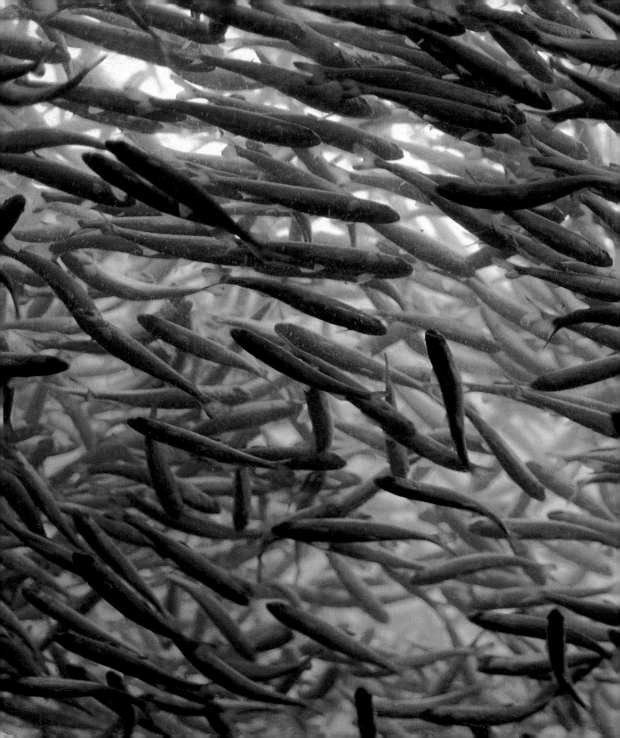

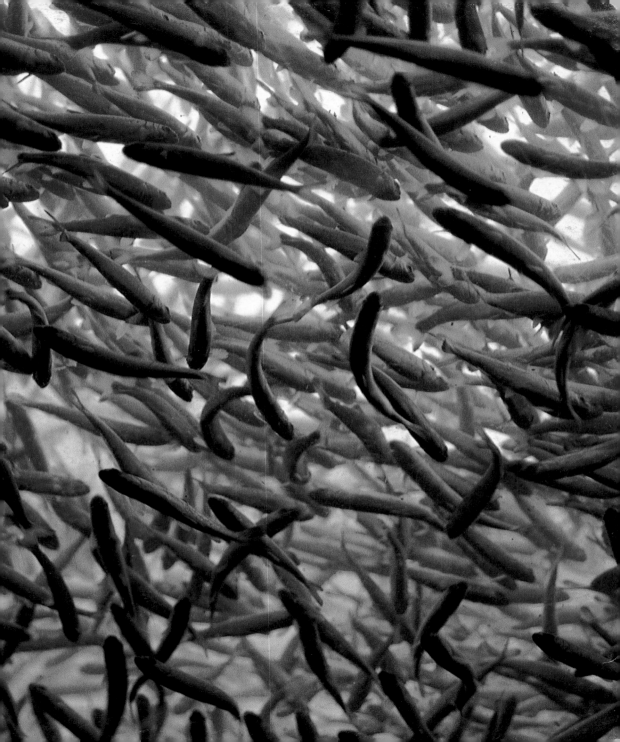

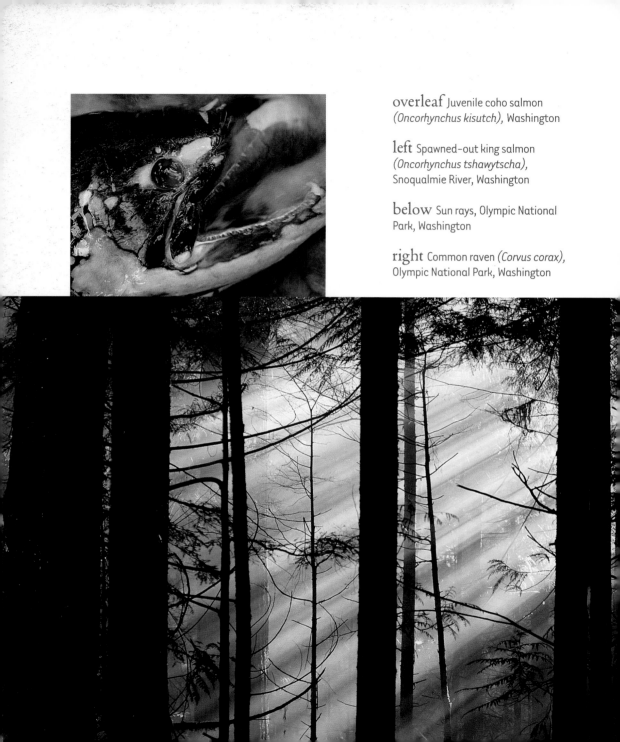

overleaf Juvenile coho salmon *(Oncorhynchus kisutch)*, Washington

left Spawned-out king salmon *(Oncorhynchus tshawytscha)*, Snoqualmie River, Washington

below Sun rays, Olympic National Park, Washington

right Common raven *(Corvus corax)*, Olympic National Park, Washington

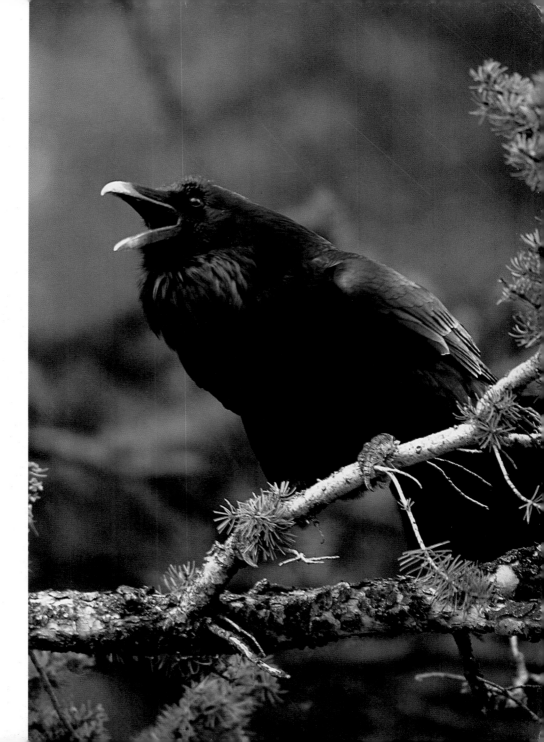

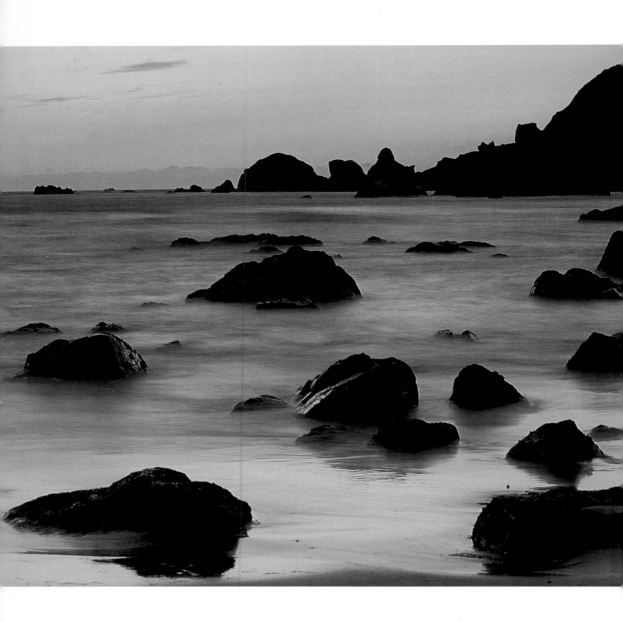

left Sunset, Harris Beach State Park, Oregon

right Storm clouds over Mt. Mystery, Olympic National Park, Washington

below Oxalis *(Oxalis oregana),* Hoh Rain Forest, Olympic National Park, Washington

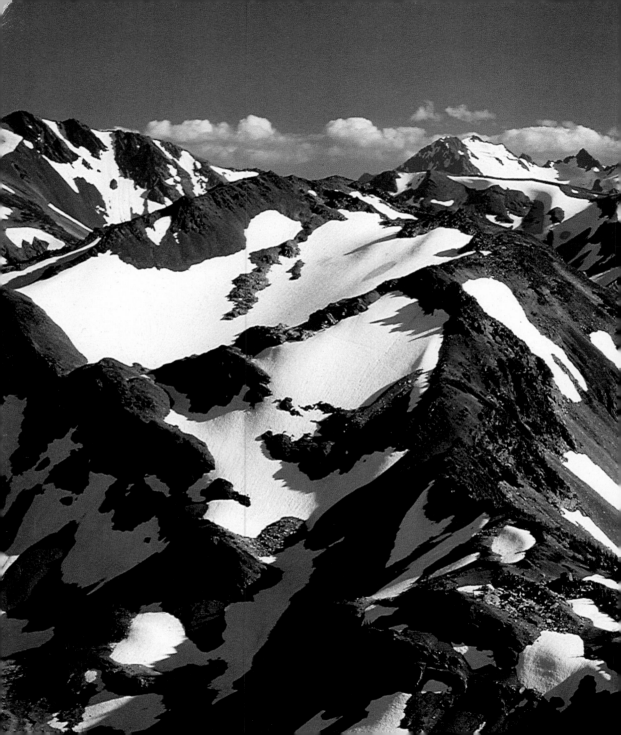

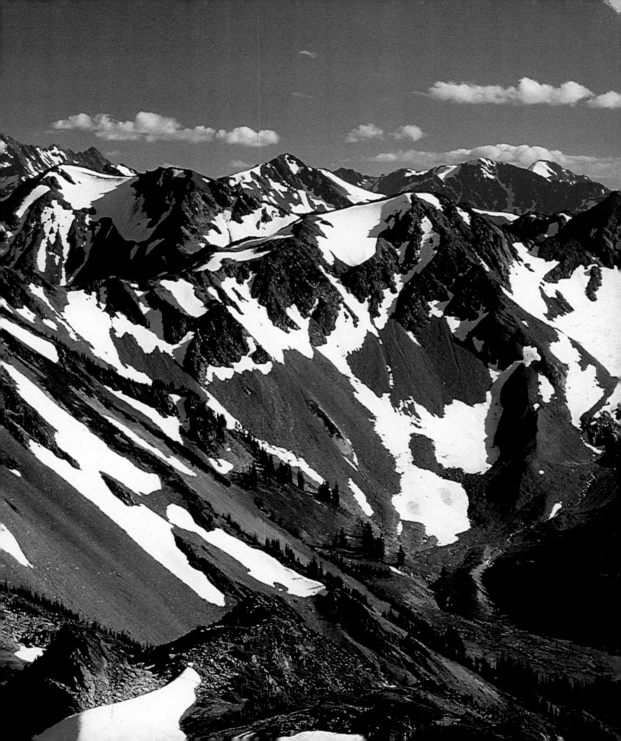

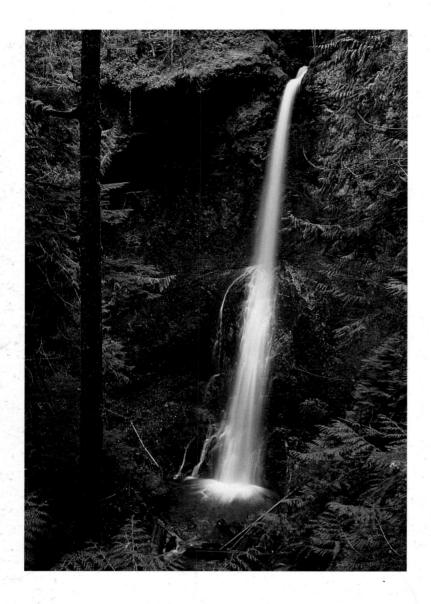

overleaf Olympic Mountains, Olympic National Park, Washington

left Marymere Falls, Olympic National Park, Washington

right Sol Duc River tributary, Olympic National Park, Washington

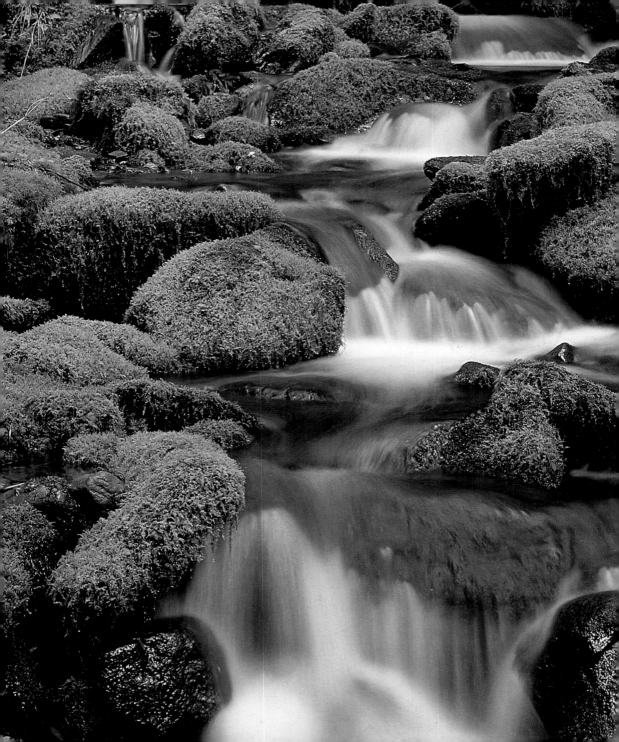

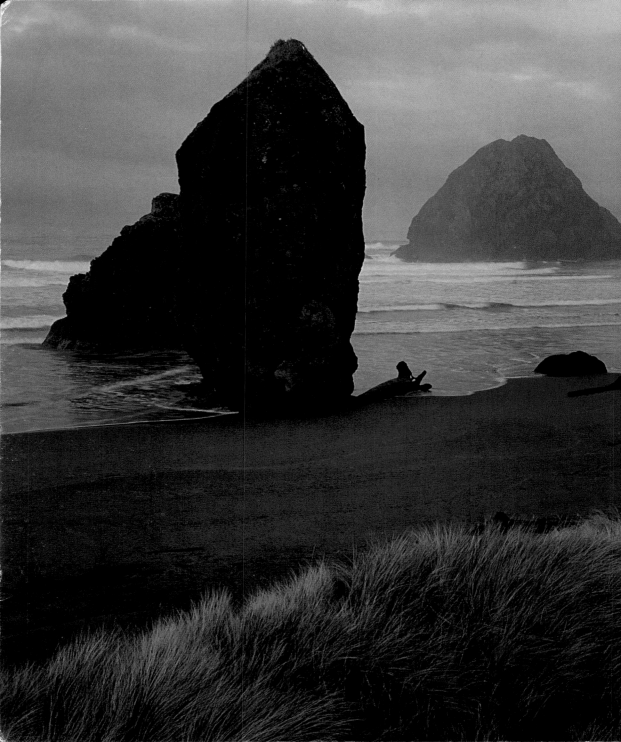

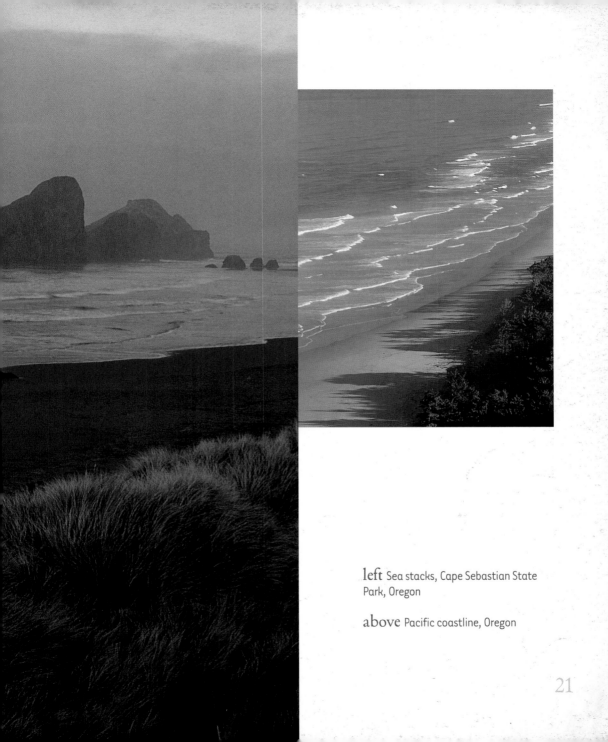

left Sea stacks, Cape Sebastian State Park, Oregon

above Pacific coastline, Oregon

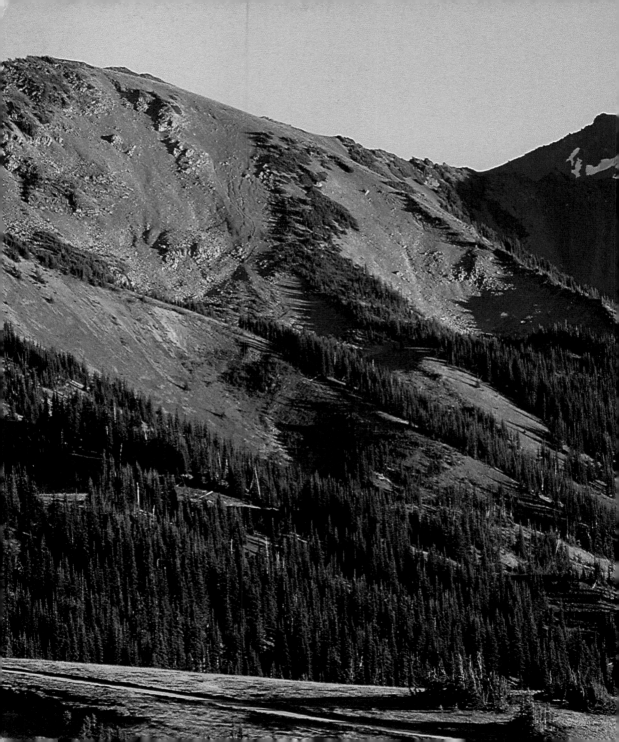

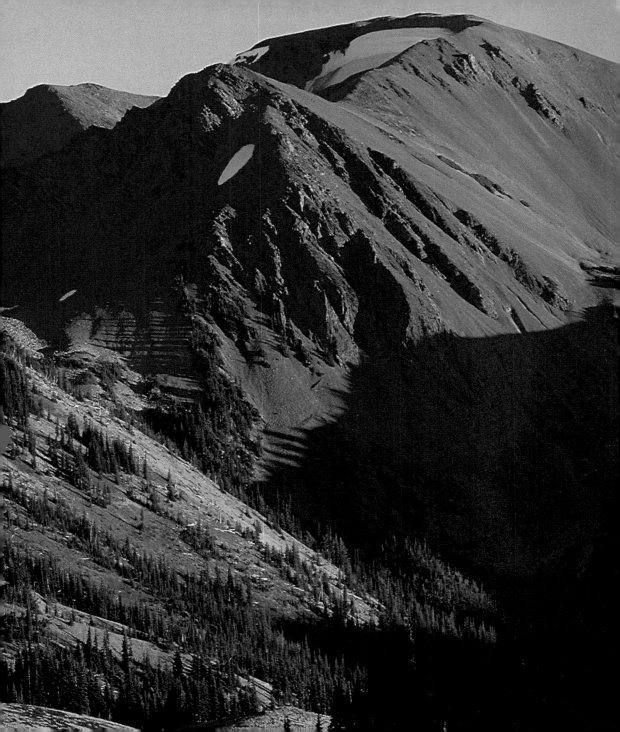

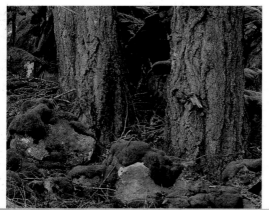

overleaf Obstruction Point area, Olympic National Park, Washington

left Douglas fir *(Pseudotsuga menziesii)* trunks, San Juan Island, Washington

below Breaching orca calf *(Orcinus orca)*, San Juan Islands, Washington

right Poppies, San Juan Island, Washington

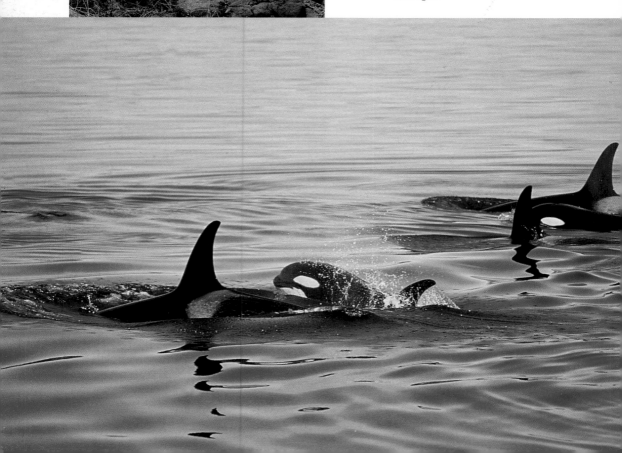

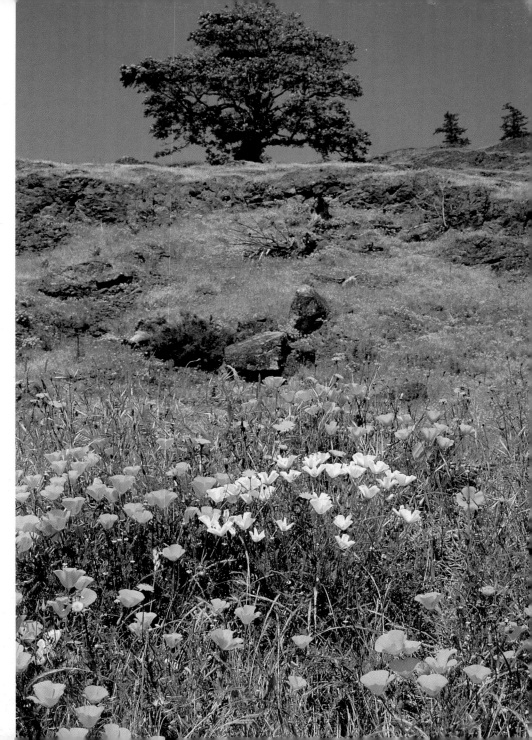

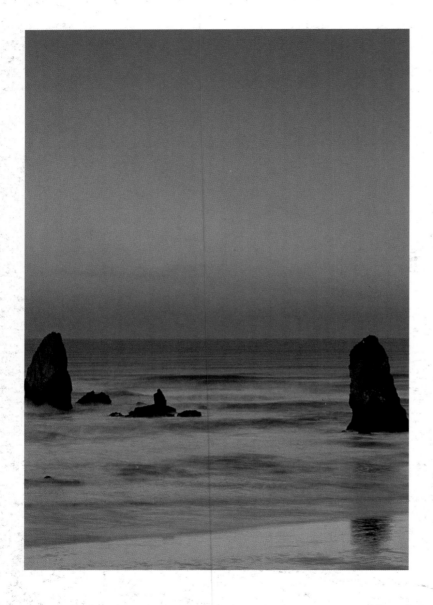

left Sea stacks, Cannon Beach, Oregon

right Long Beach, Washington

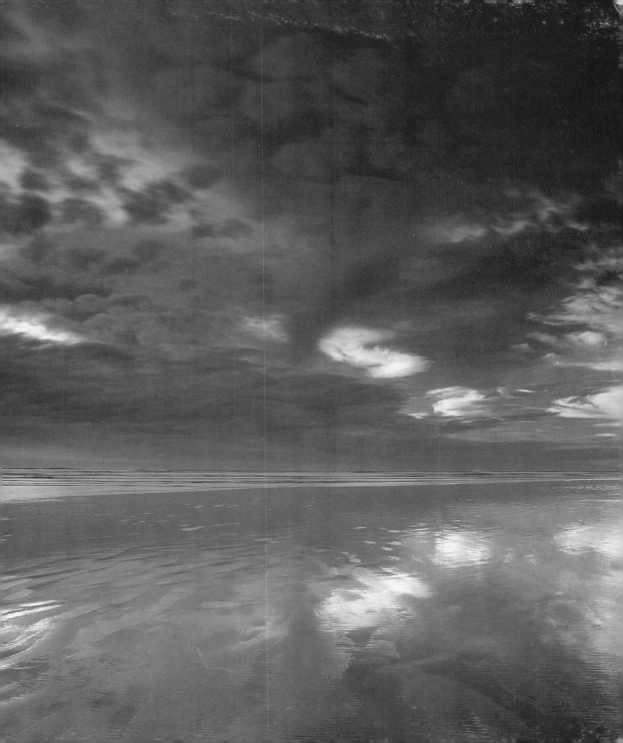

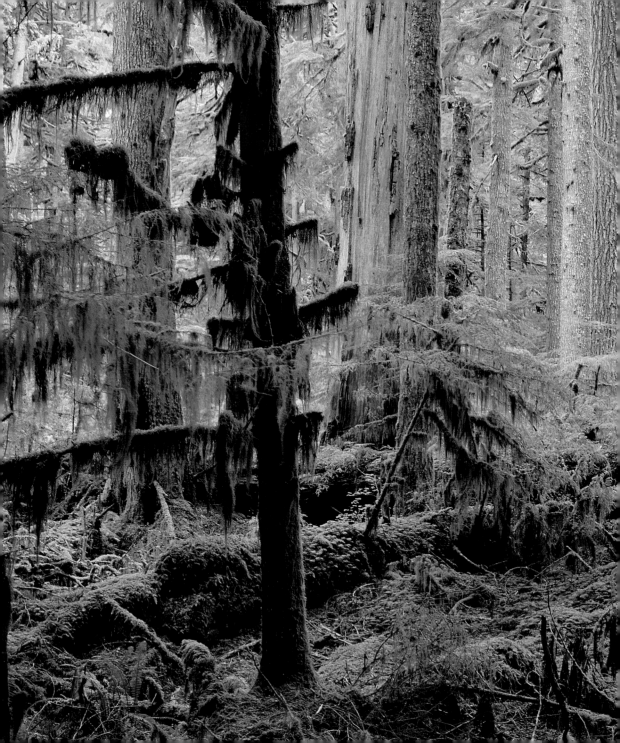

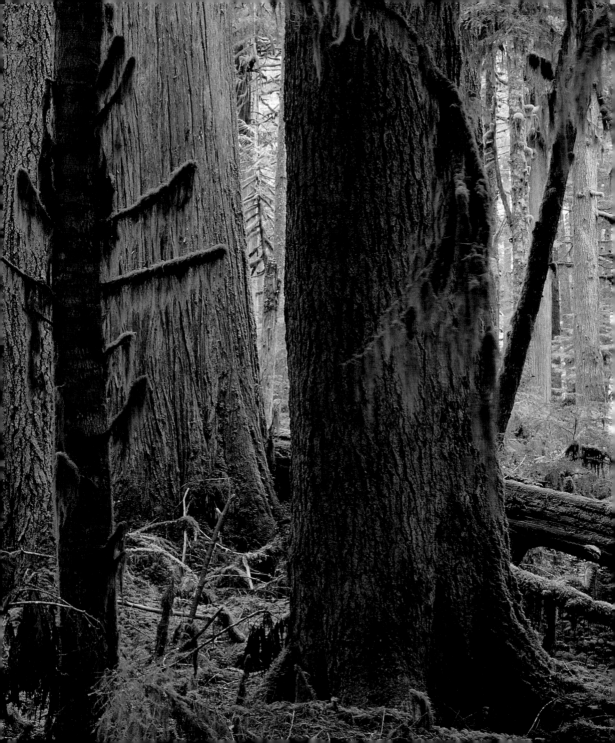

overleaf Hoh Rain Forest, Olympic National Park, Washington

left Oak ferns *(Gymnocarpium dryopteris)*, Hoh Rain Forest, Olympic National Park, Washington

below Pacific madrone *(Arbutus menziesii)*, San Juan Island, Washington

right Short-billed dowitchers *(Limnodromus griseus)*, Grays Harbor National Wildlife Refuge, Washington

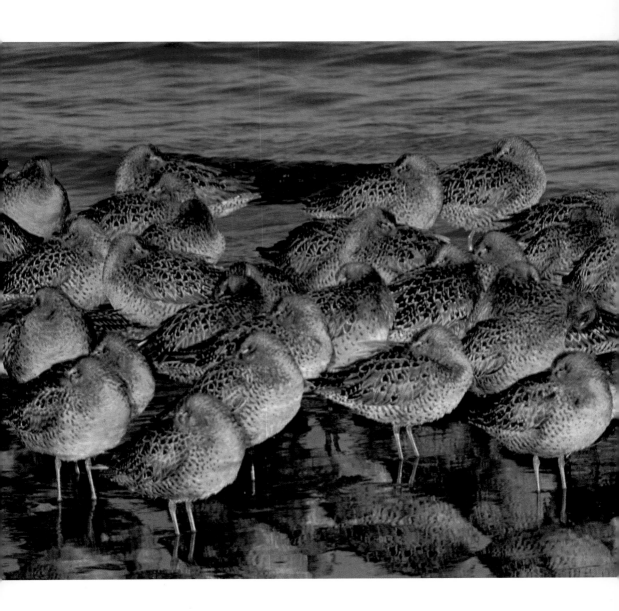

{ cascades }

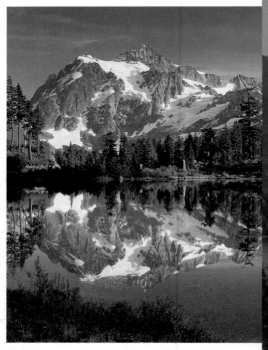

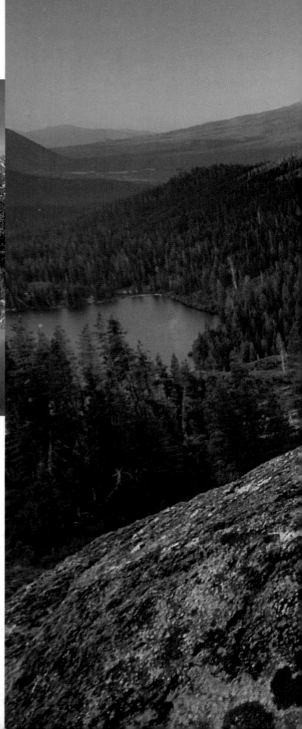

overleaf Christine Falls, Mt. Rainier
National Park, Washington

above Mt. Shuksan, Mt. Baker–
Snoqualmie National Forest, Washington

right Mt. Shasta, Mt. Shasta
Wilderness, California

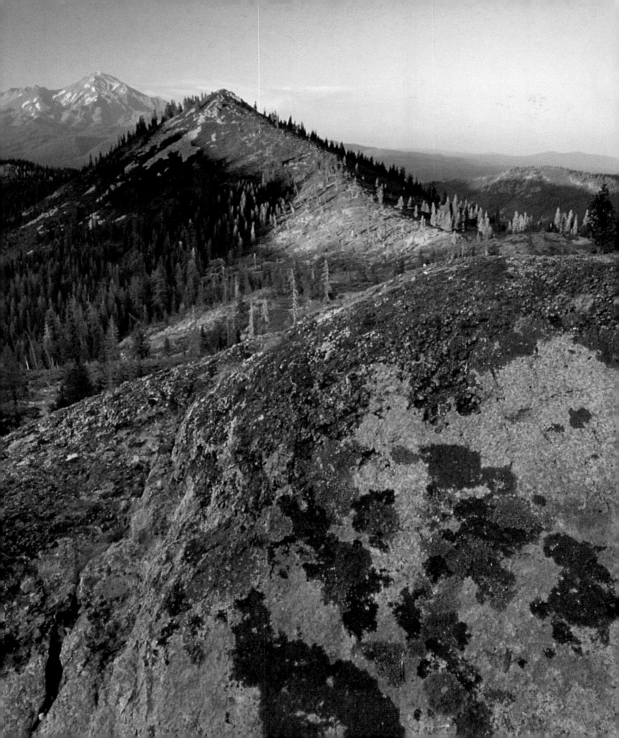

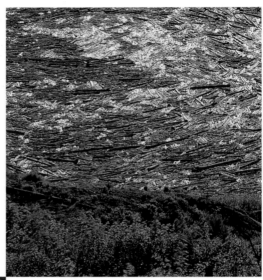

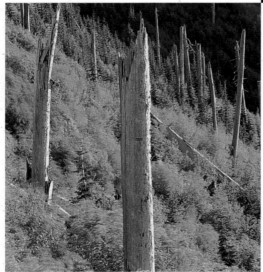

left Blown down forest and
regrowth, Mt. St. Helens National
Volcanic Monument, Washington

above Logs in Spirit Lake, Mt. St. Helens
National Volcanic Monument, Washington

right Mt. St. Helens from Windy
Ridge, Mt. St. Helens National Volcanic
Monument, Washington

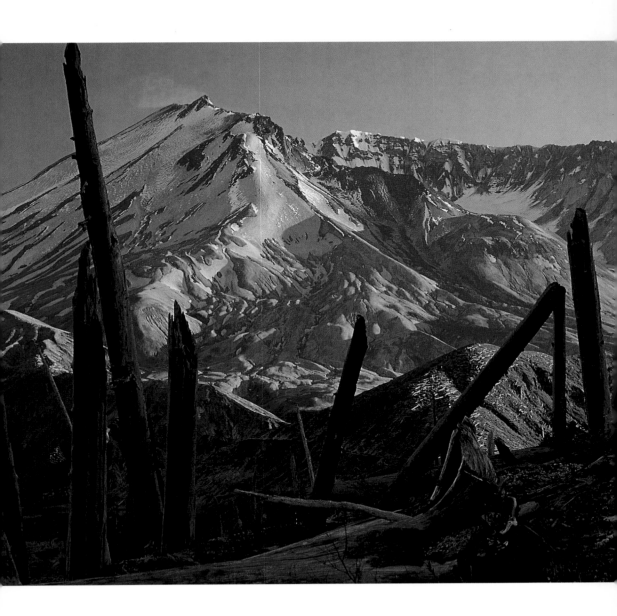

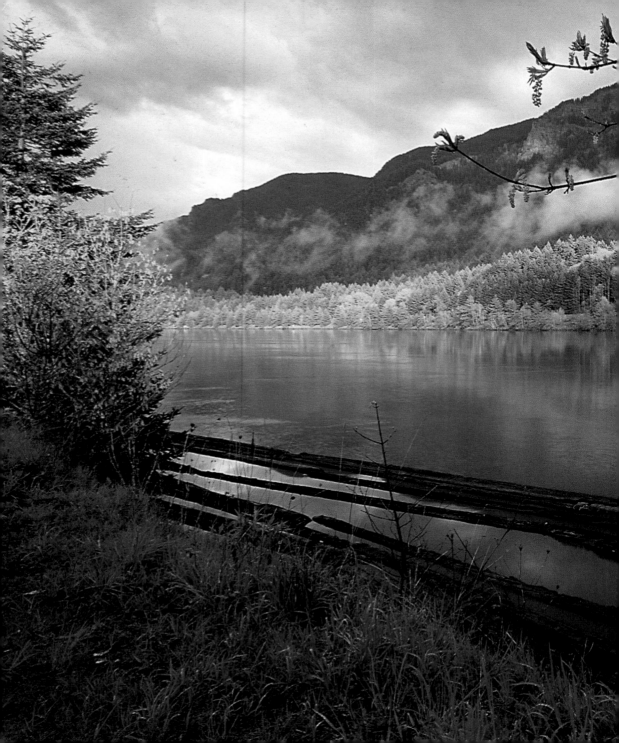

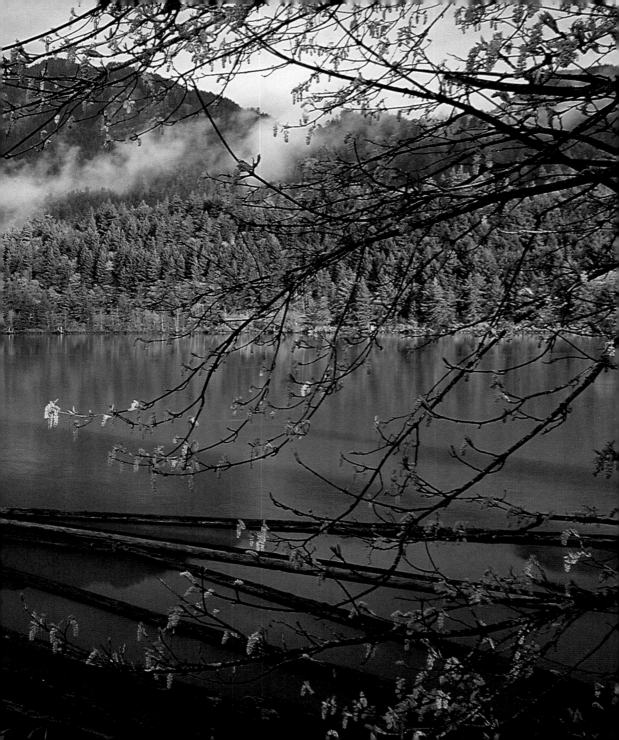

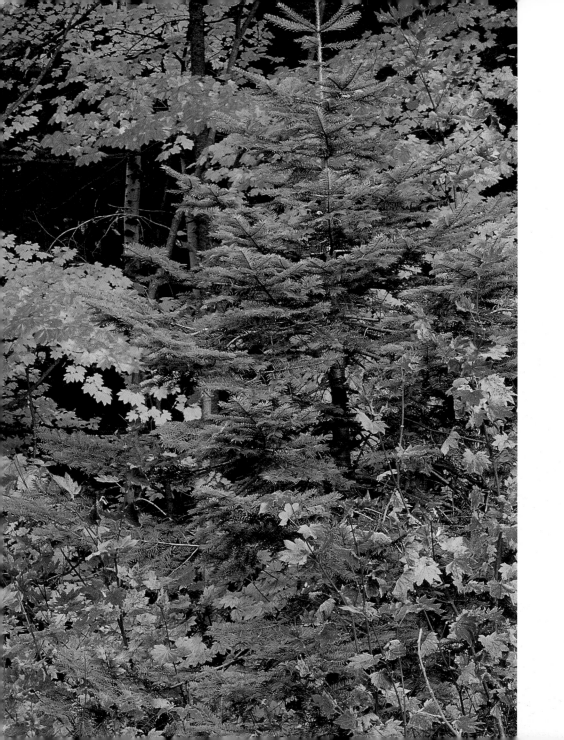

overleaf Columbia River, Columbia River Gorge
National Scenic Area, Oregon and Washington

left Fall colors, Cascade Range, Washington

right Fall colors, Mt. Baker Wilderness Area,
Washington

below Pacific tree frog *(Hyla regilla)*, Mt.
Baker–Snoqualmie National Forest, Washington

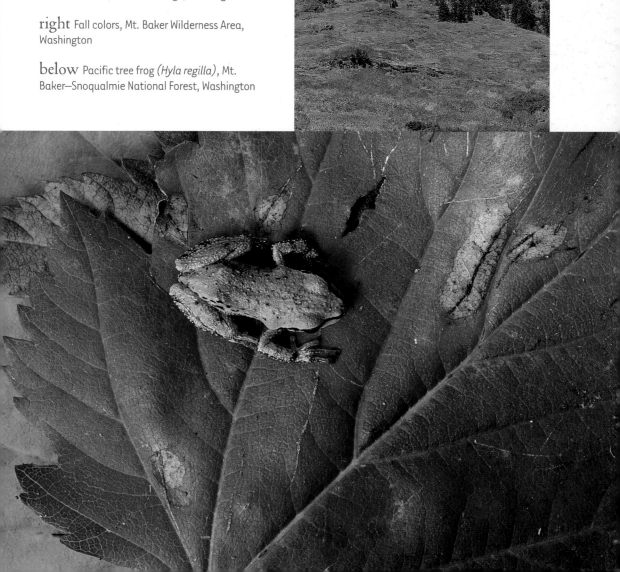

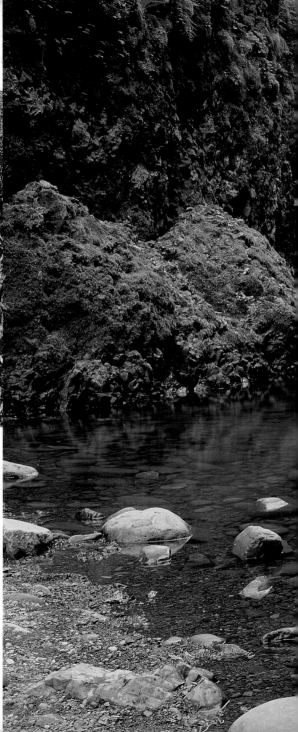

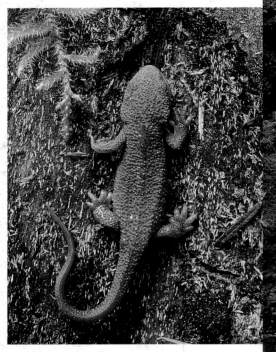

above Rough-skinned newt
(Taricha granulosa), Cascade Range,
Washington

right Punch Bowl Falls, Columbia
River Gorge National Scenic Area,
Oregon

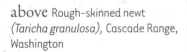

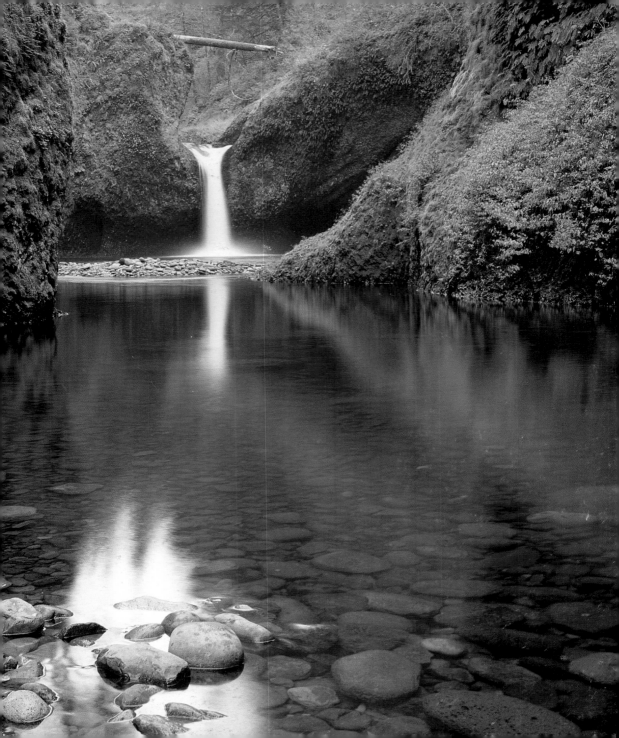

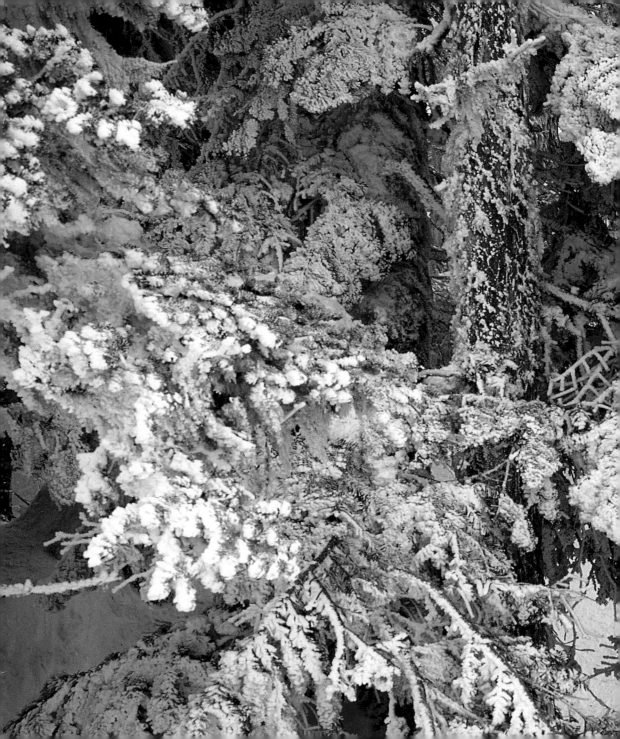

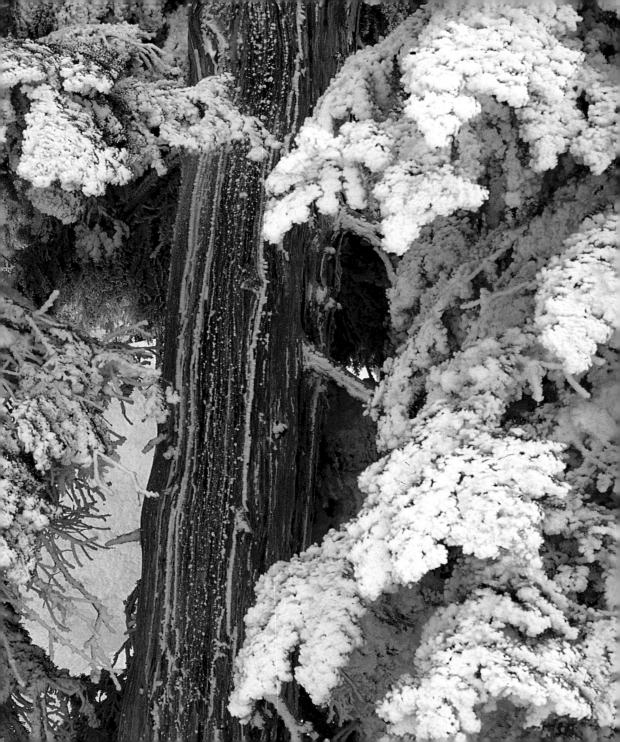

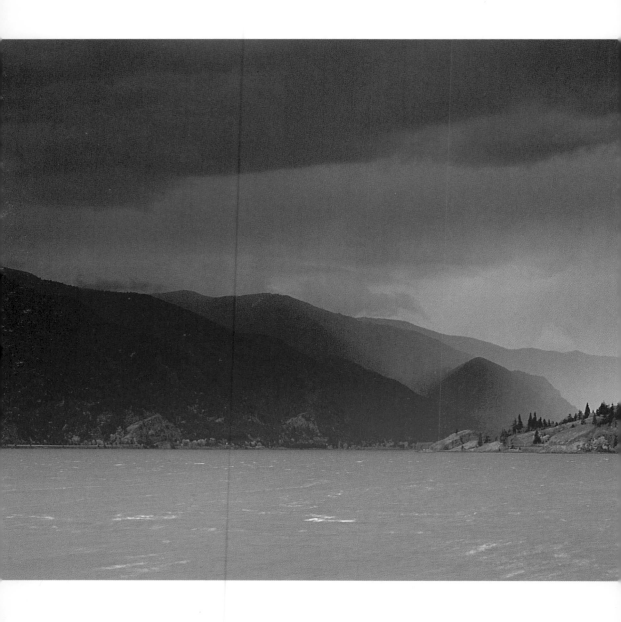

overleaf Winterscape, Mt. Rainier National Park, Washington

left Spring storm, Columbia River Gorge National Scenic Area, Oregon and Washington

right Metlako Falls, Eagle Creek, Columbia River Gorge National Scenic Area, Oregon

below Red fox *(Vulpes vulpes)*, Cascade Range, Oregon

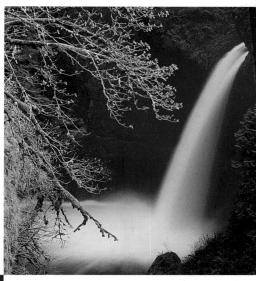

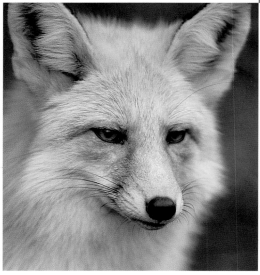

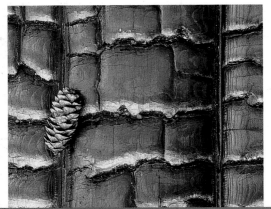

left Fir cone on charred log, Cascade Range, Washington

below Mt. Adams, Gifford Pinchot National Forest, Washington

right Mt. Rainier and wildflowers, Mt. Rainier National Park, Washington

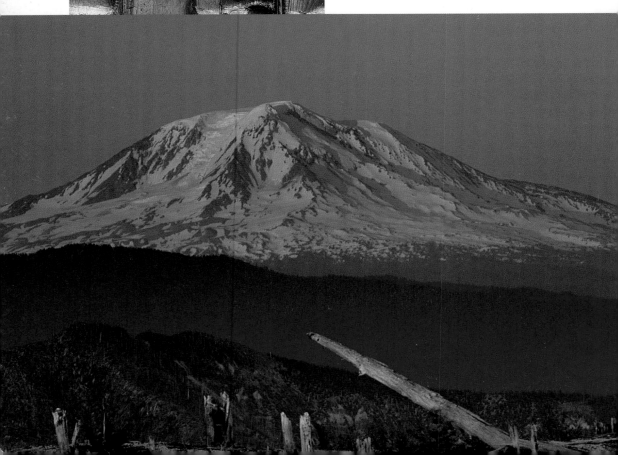

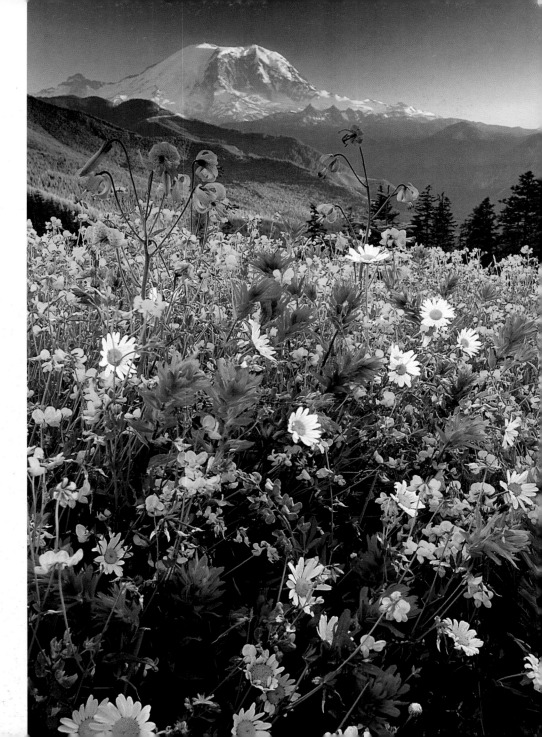

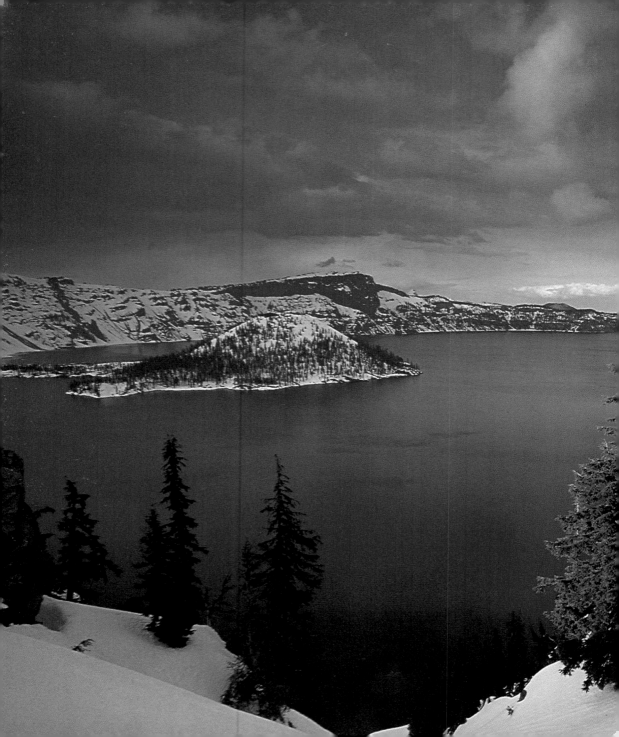

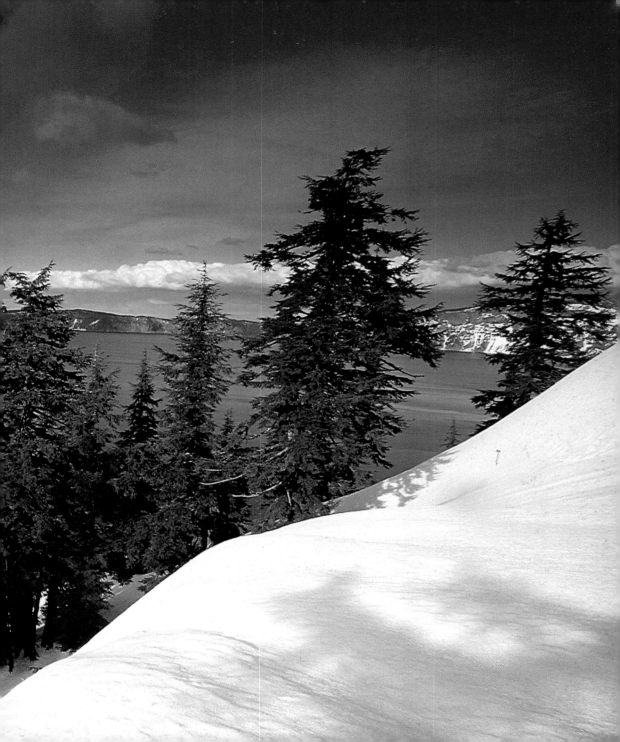

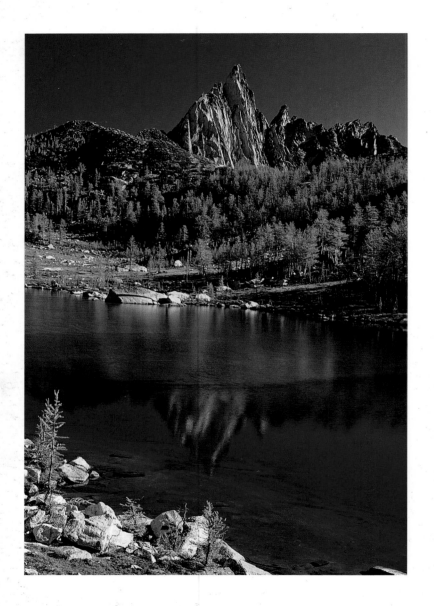

overleaf Crater Lake, Crater Lake National Park, Oregon

left Prusik Peak, Enchantment Lakes Basin, Alpine Lakes Wilderness, Washington

right Cougar *(Felis concolor)*, Siskiyou National Forest, Oregon

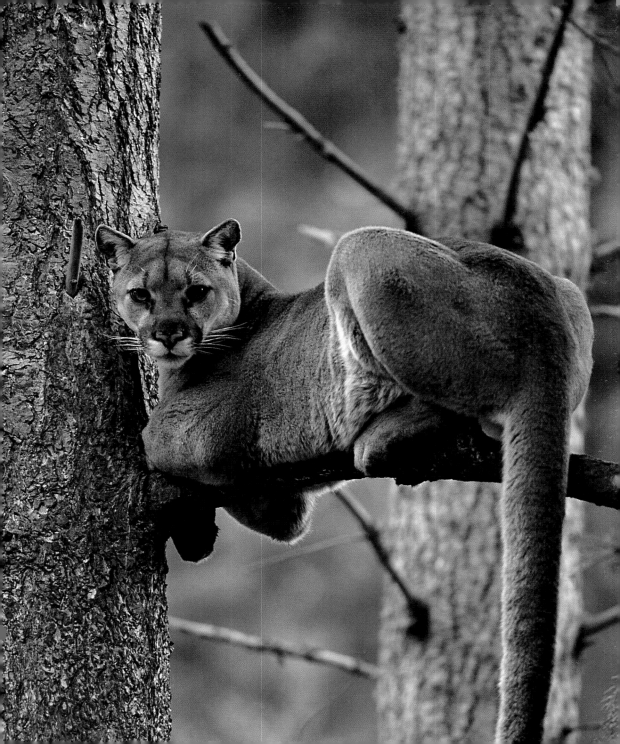

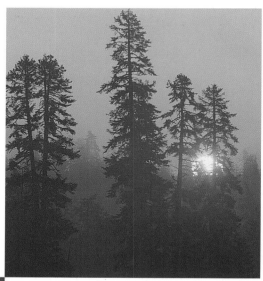

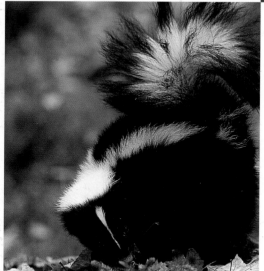

left Striped skunk *(Mephitis mephitis)*, Cascade Range, California

above Sunset through forest-fire haze, Lassen Volcanic National Park, California

right Lassen Peak, Lassen Volcanic National Park, California

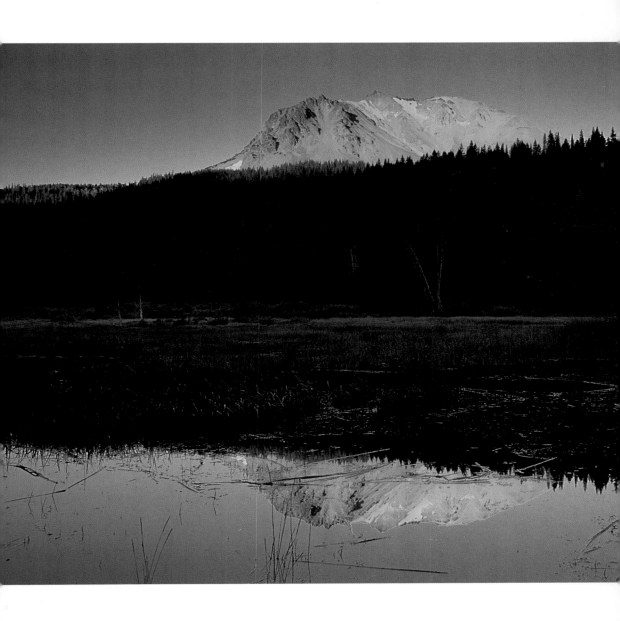

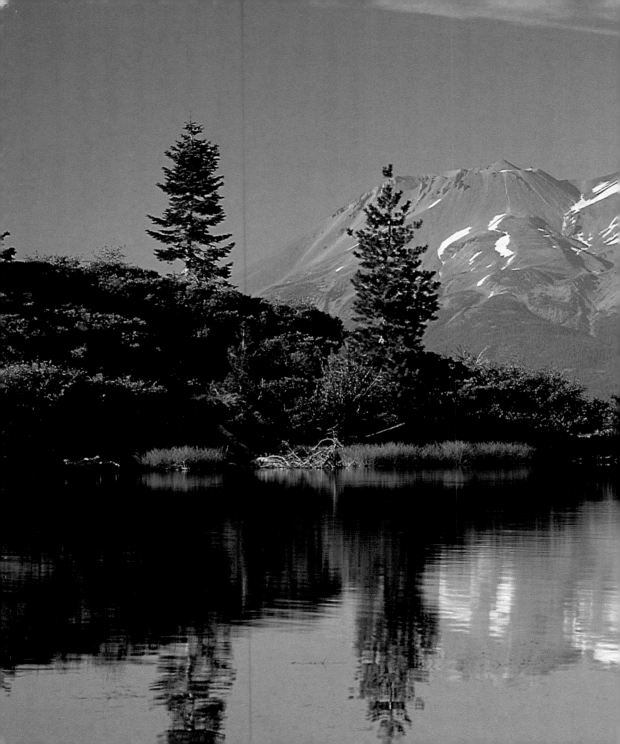

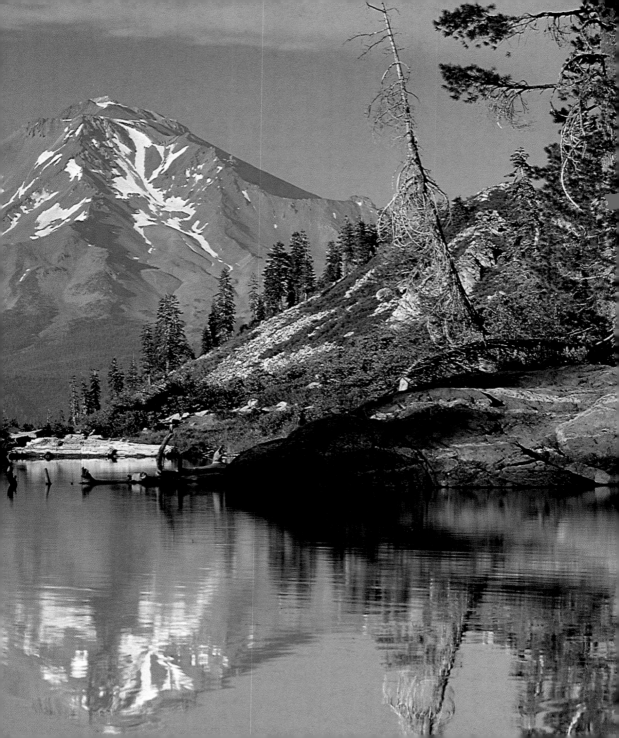

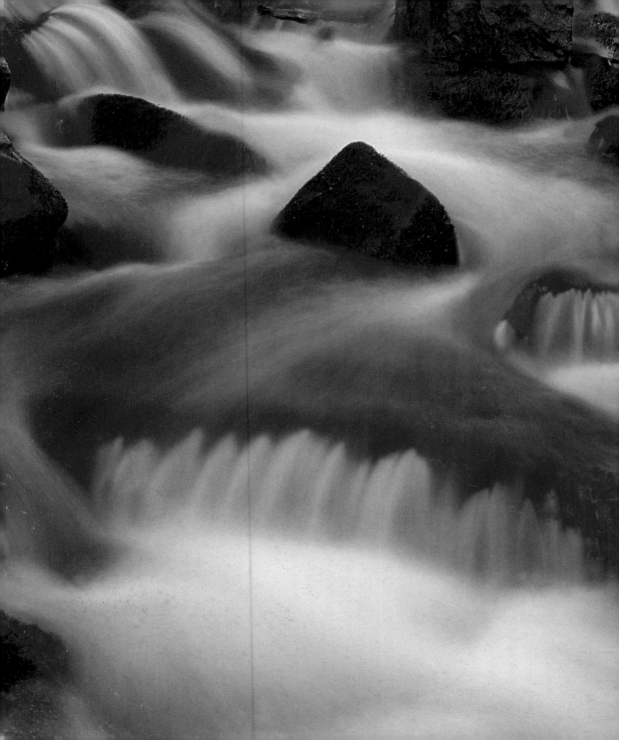

overleaf Mt. Shasta, Mt. Shasta Wilderness, California

left Stream, Mt. Baker Wilderness Area, Washington

right Icicle Creek, Cascade Range, Washington

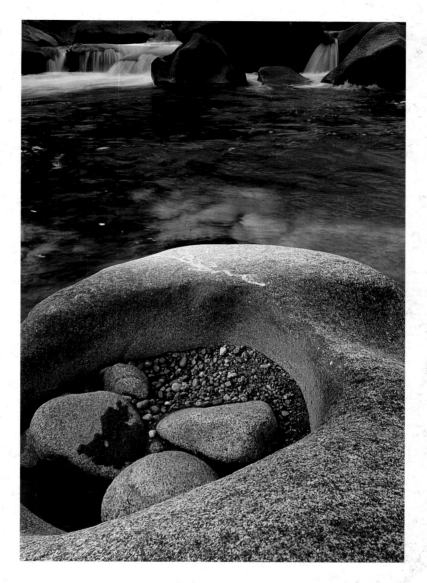

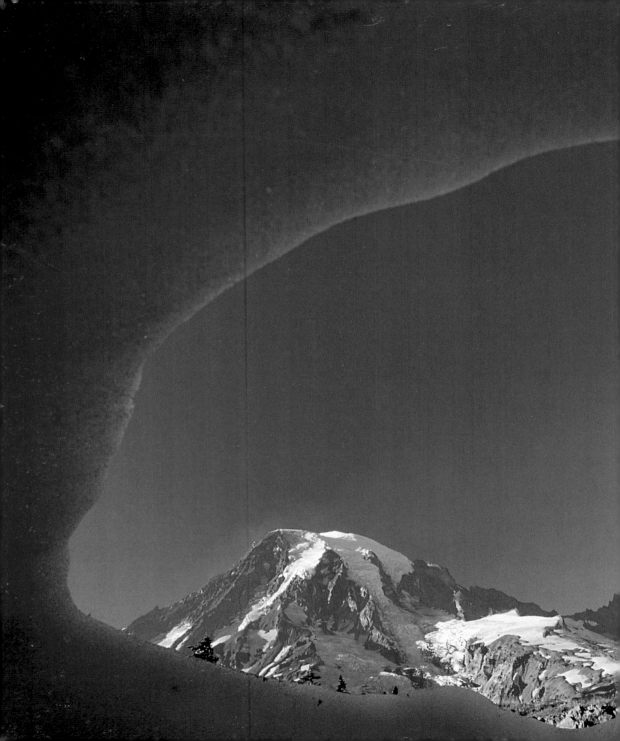

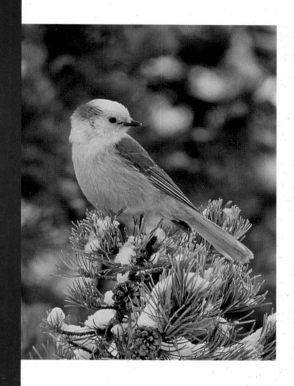

left Mt. Rainier, Mt. Rainier National
Park, Washington

above Gray jay *(Perisoreus
canadensis)*, Mt. Rainier National
Park, Washington

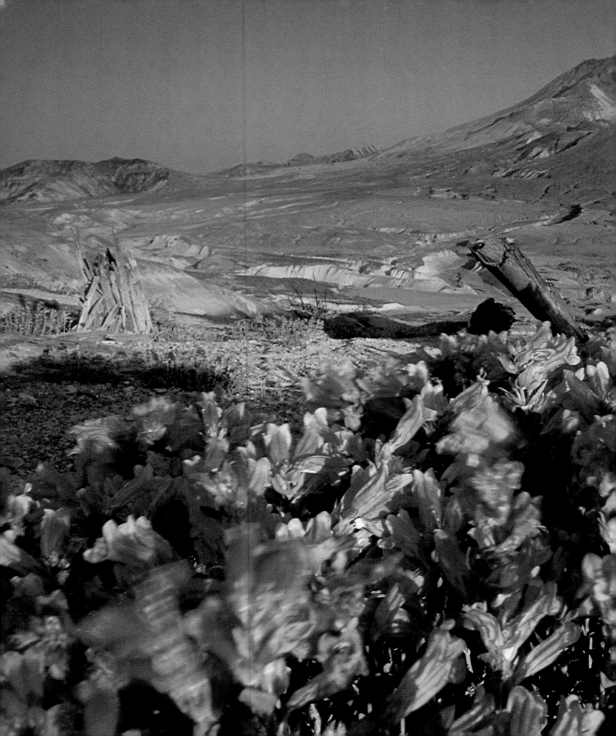

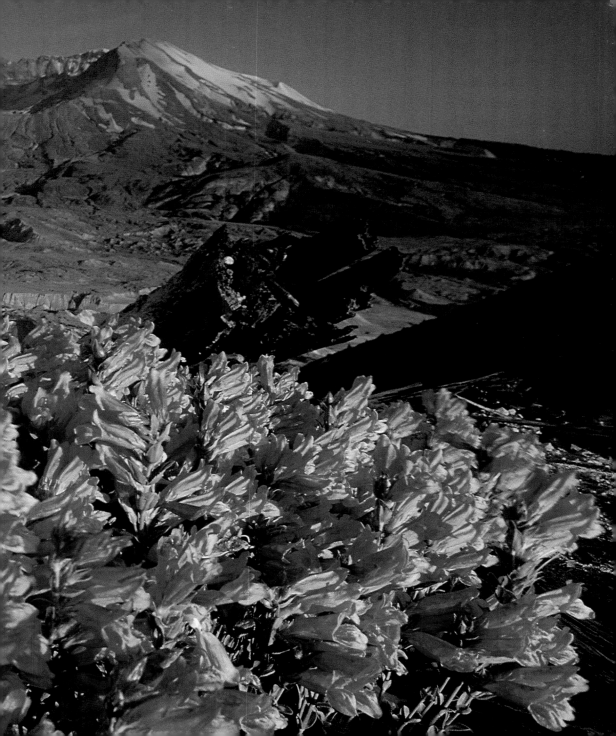

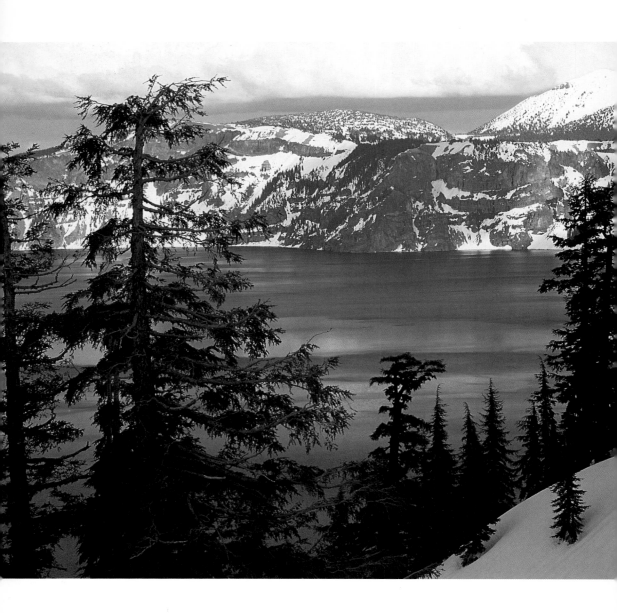

overleaf Cliff penstemon *(Penstemon rupicola)*, Mt. St. Helens National Volcanic Monument, Washington

left Crater Lake, Crater Lake National Park, Oregon

right Snowshoe hare *(Lepus americanus)*, Cascade Range, Oregon

below Pine marten *(Martes martes)*, Cascade Range, Oregon

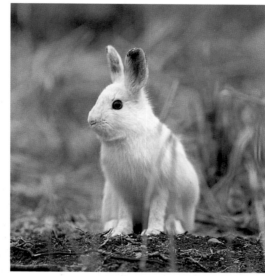

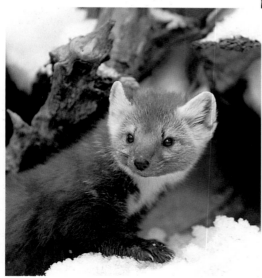

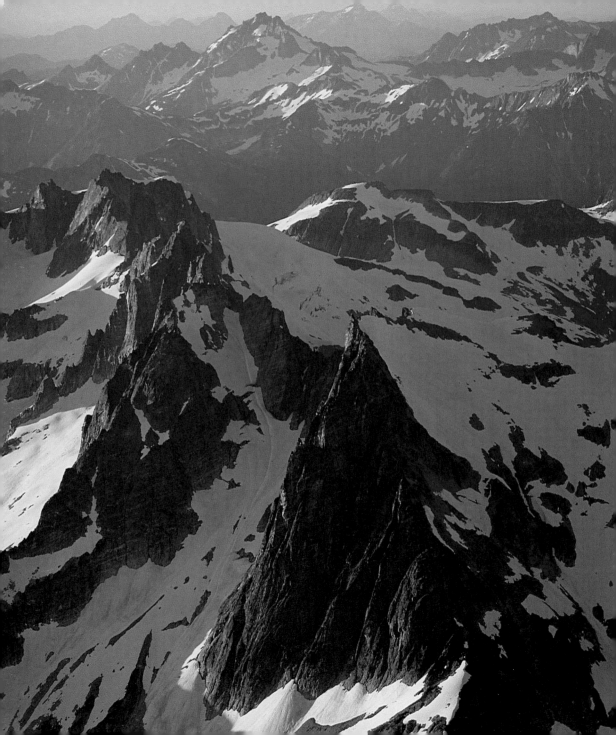

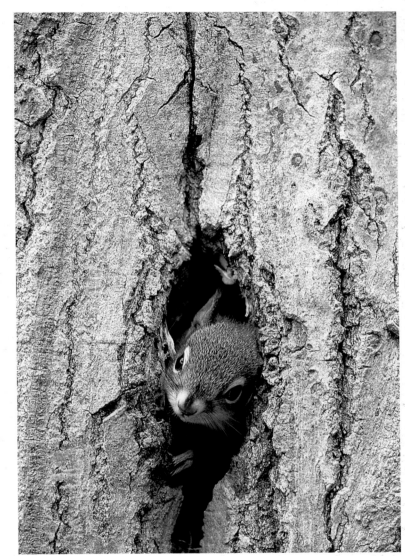

left The Picketts, North Cascades National Park, Washington

right Red squirrel *(Tamiasciurus hudsonicus),* Cascade Range, Washington

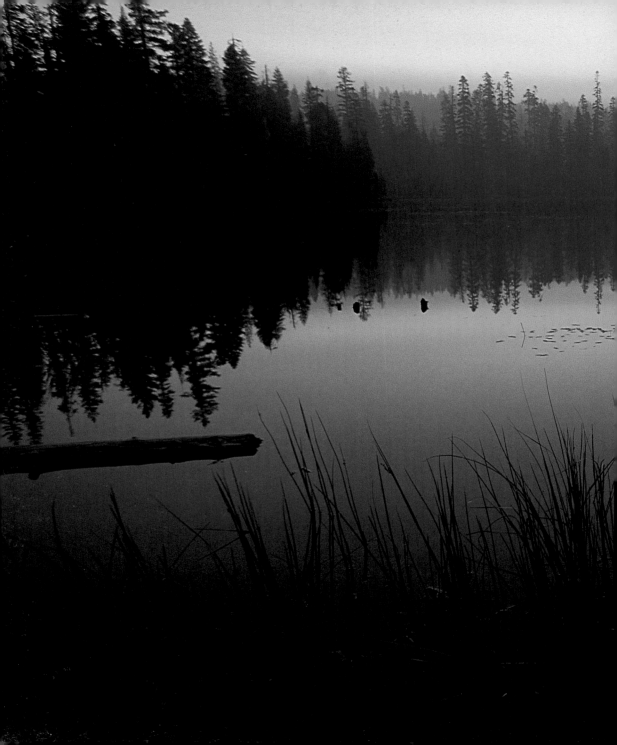

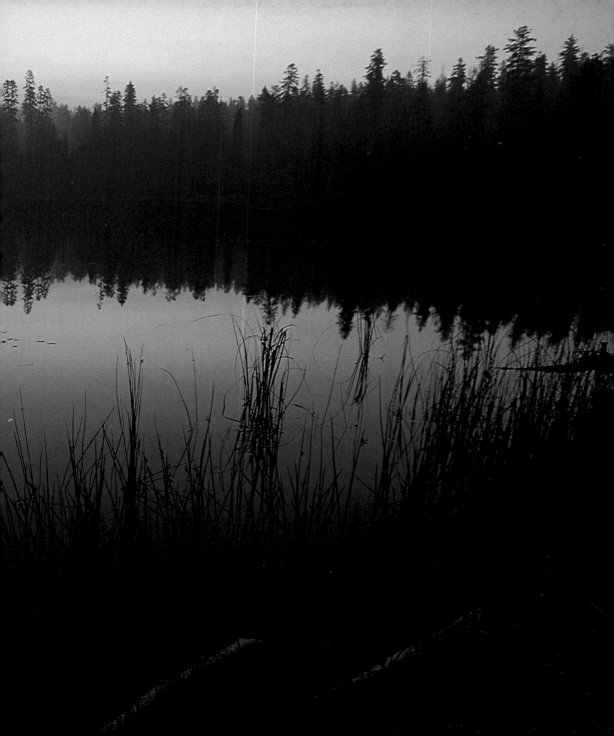

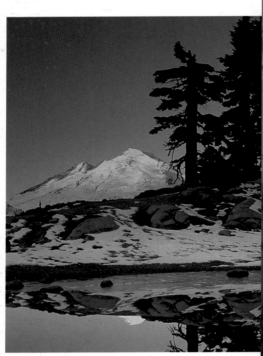

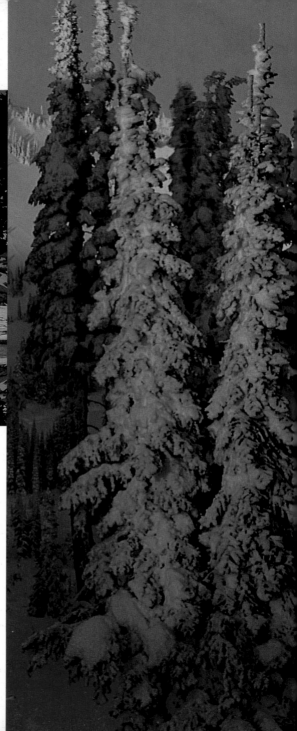

overleaf Lake, Lassen Volcanic
National Park, California

above Mt. Baker, Mt. Baker
Wilderness Area, Washington

right Winterscape, Mt. Rainier
National Park, Washington

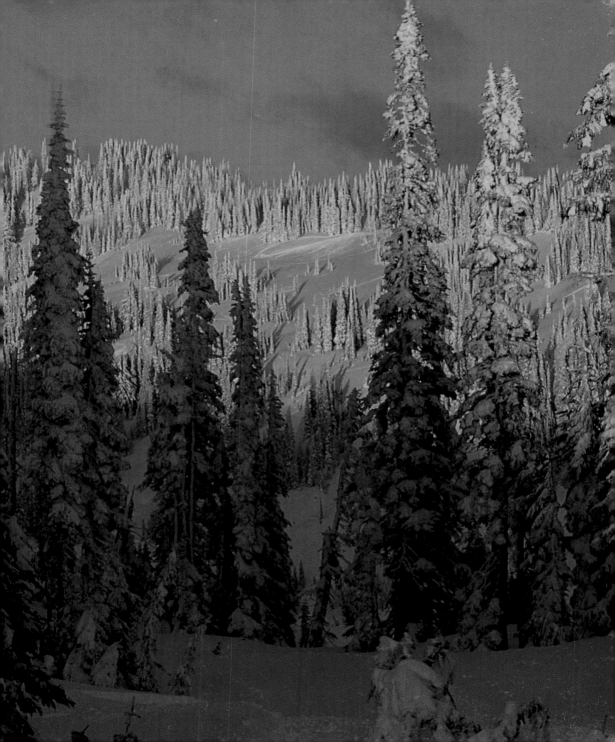

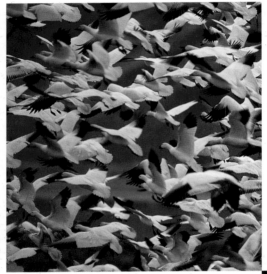

left Snow geese *(Chen caerulescens)*, Skagit River Valley, Washington

below Dunlins *(Calidris alpina)*, Skagit River Valley, Washington

right Snow geese *(Chen caerulescens)* in flight, Tule Lake National Wildlife Refuge, California

next page Mt. Rainier, Mt. Rainier National Park, Washington

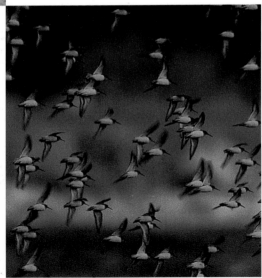

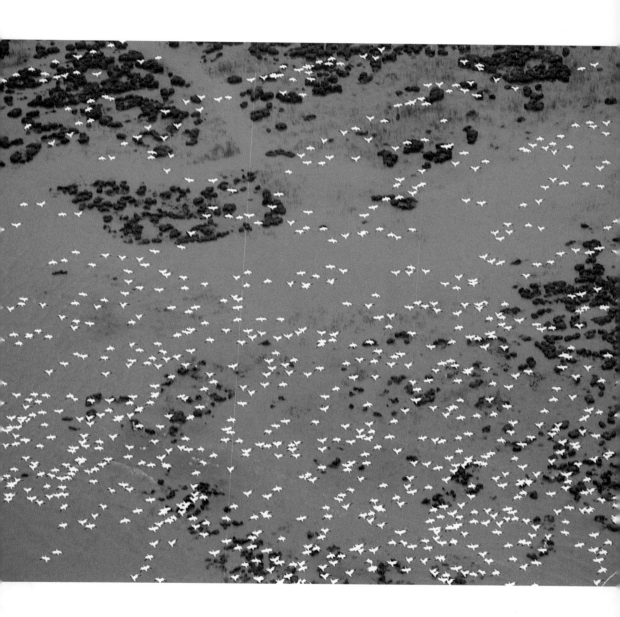

73

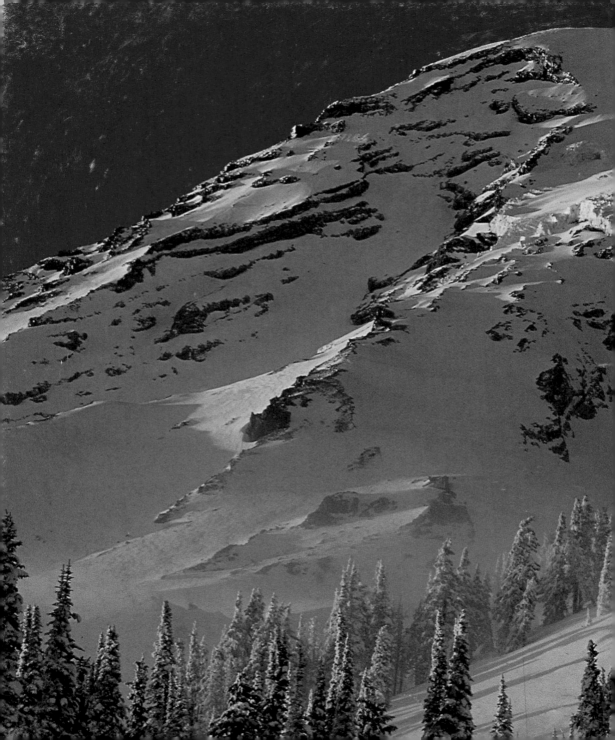

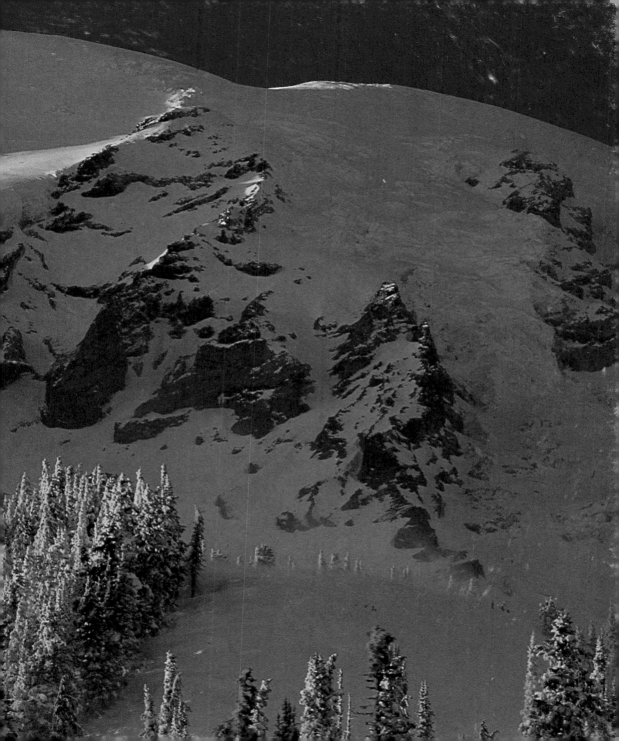

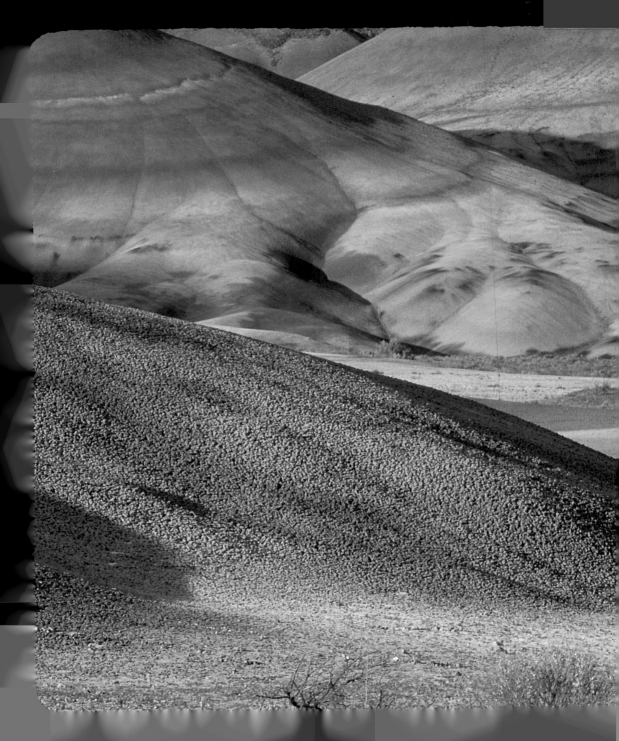

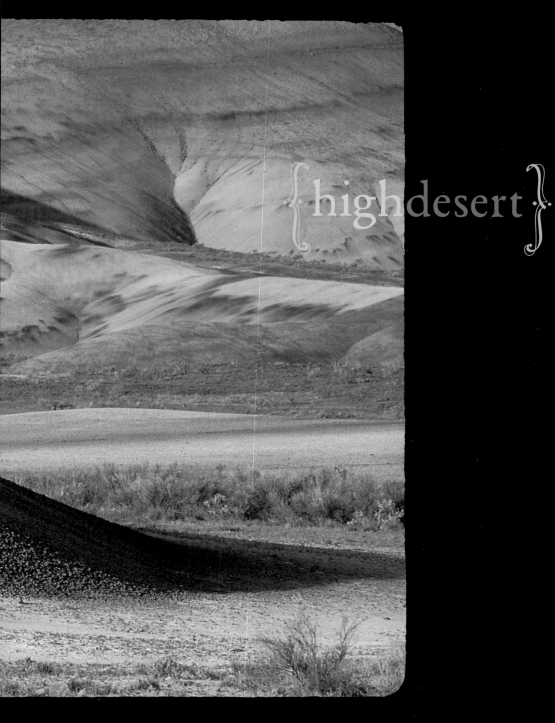

{highdesert}

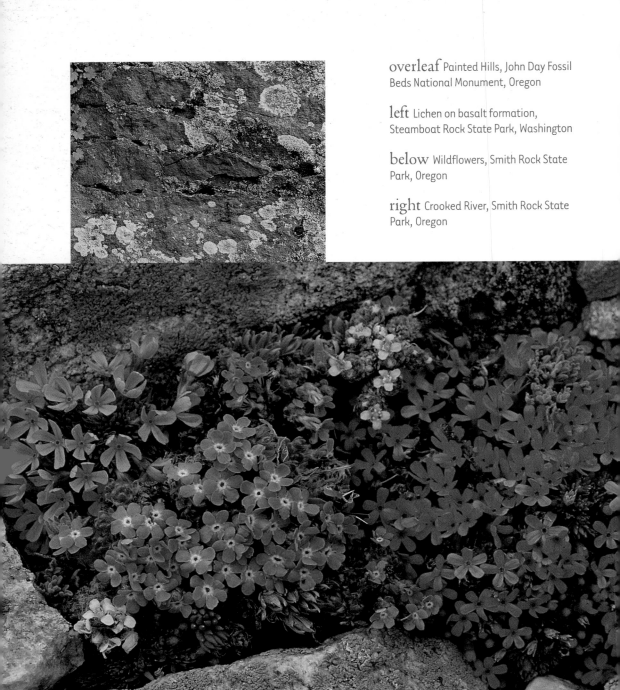

overleaf Painted Hills, John Day Fossil Beds National Monument, Oregon

left Lichen on basalt formation, Steamboat Rock State Park, Washington

below Wildflowers, Smith Rock State Park, Oregon

right Crooked River, Smith Rock State Park, Oregon

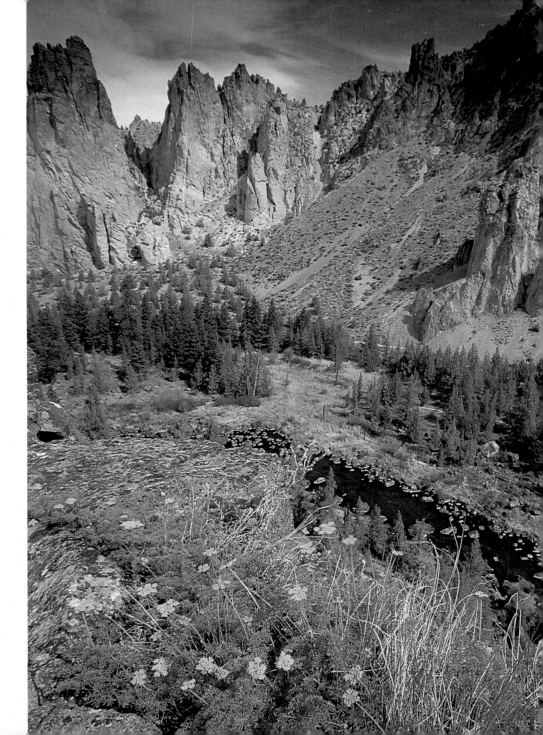

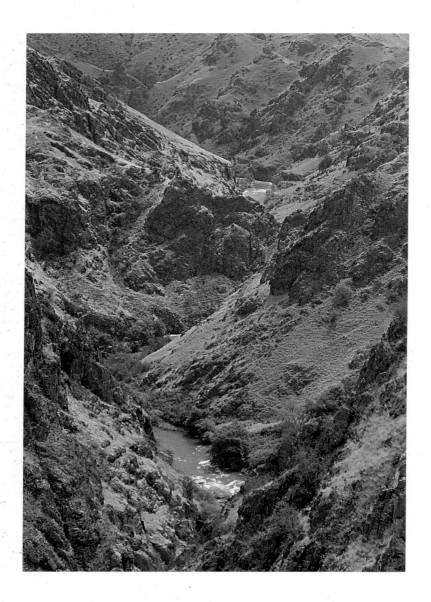

left Imnaha River,
Hells Canyon National
Recreation Area,
Oregon

right Golden eagle
(Aquila chrysaetos),
Smith Rock State Park,
Oregon

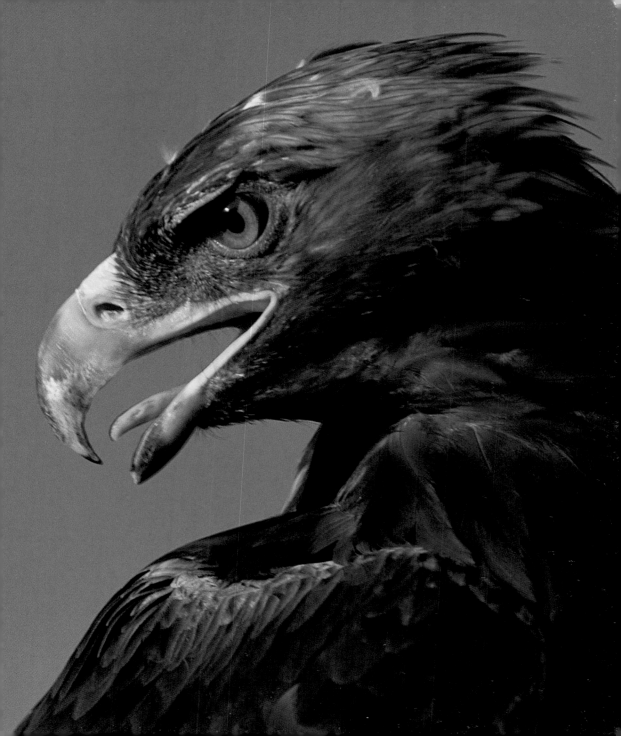

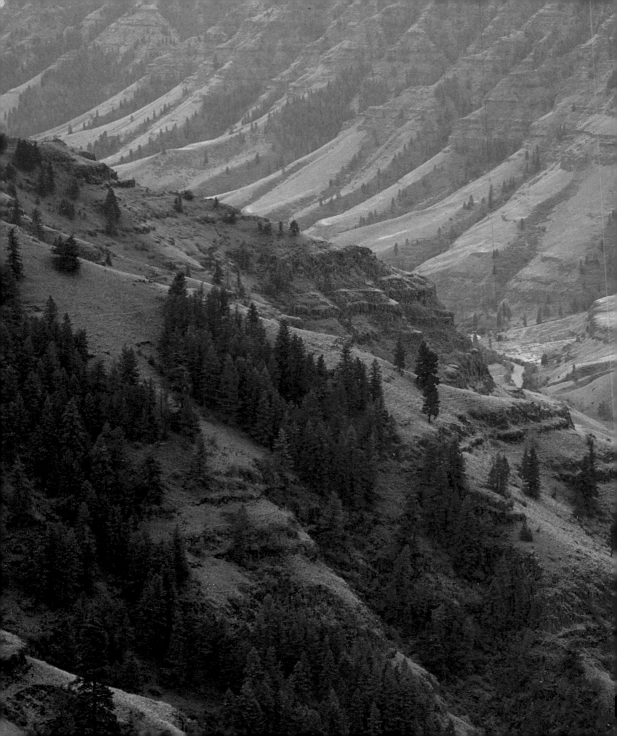

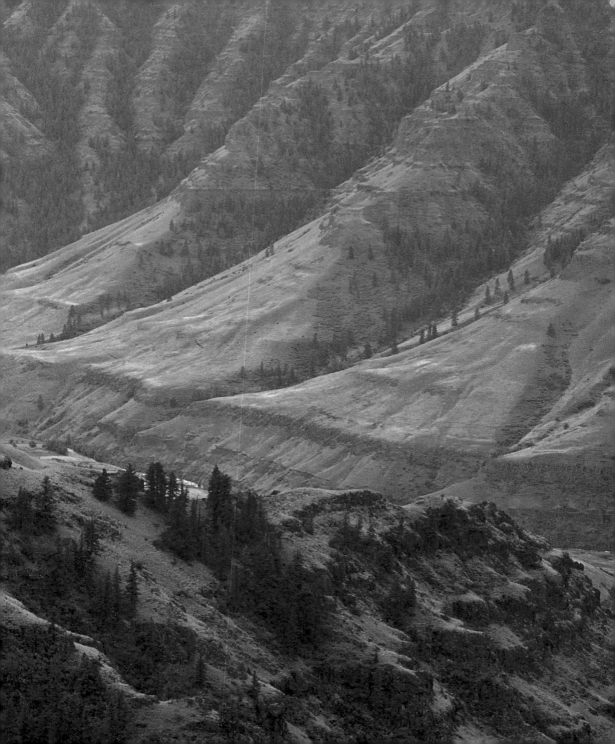

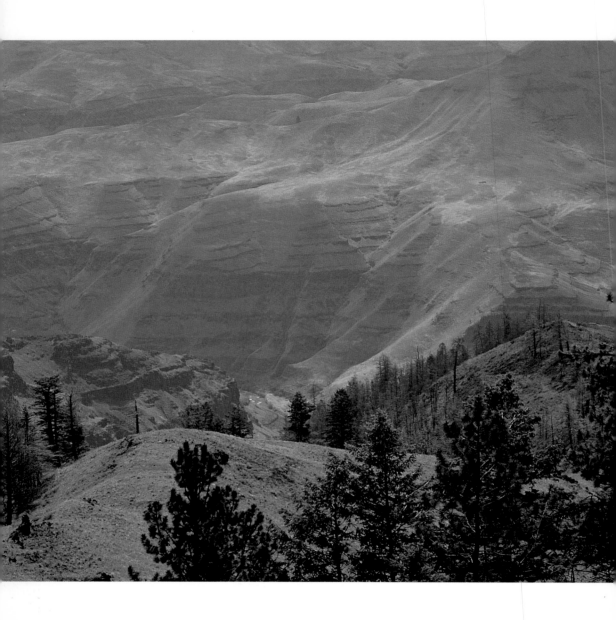

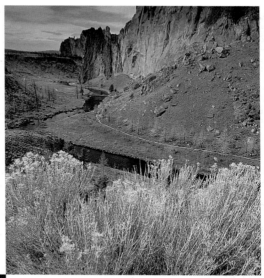

overleaf and left Imnaha River, Hells Canyon National Recreation Area, Oregon

right Crooked River, Smith Rock State Park, Oregon

below Common ravens *(Corvus corax)* on nest, Smith Rock State Park, Oregon

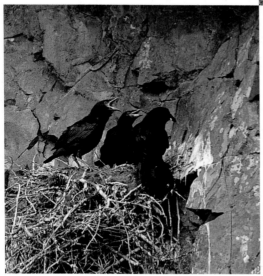

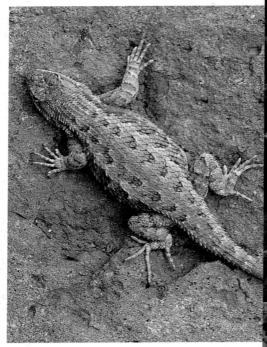

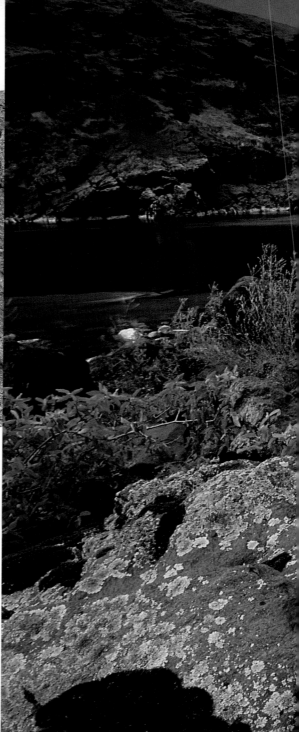

above Western fence lizard
(*Sceloporus occidentalis*), Columbia
Basin, Washington

right Snake River, Hells Canyon
National Recreation Area, Idaho and
Oregon

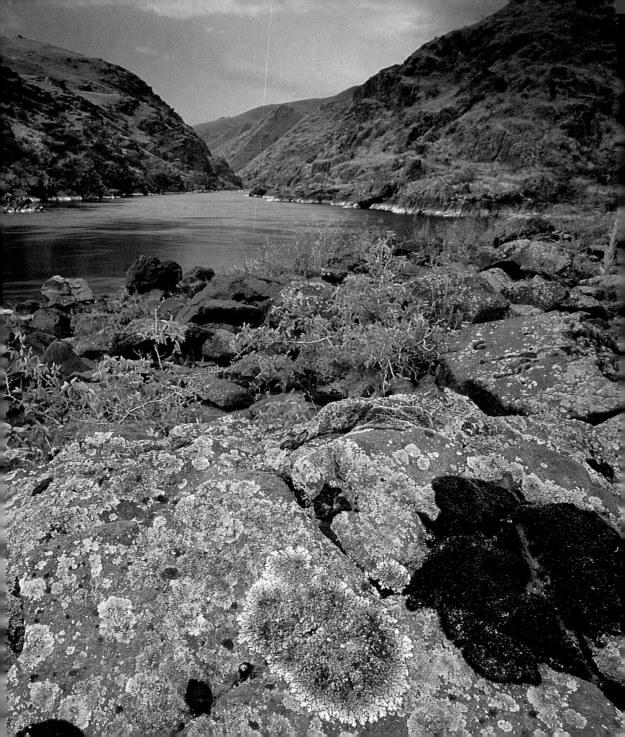

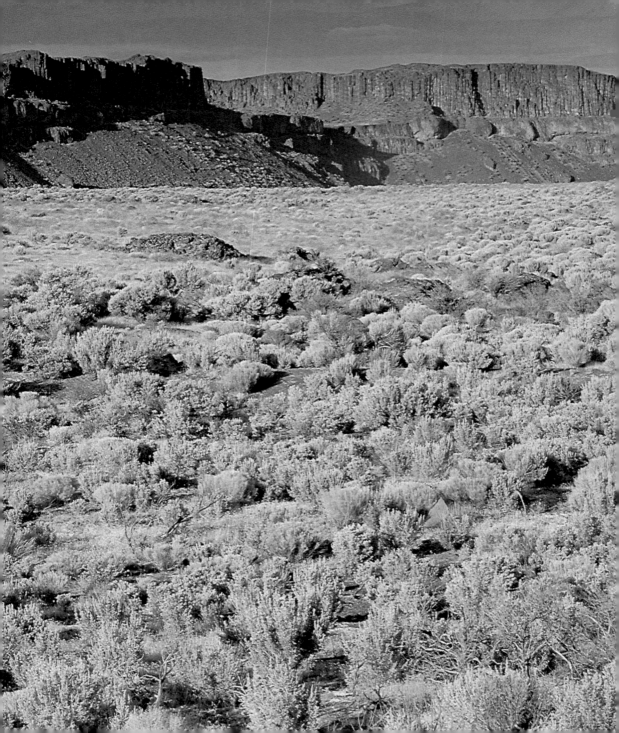

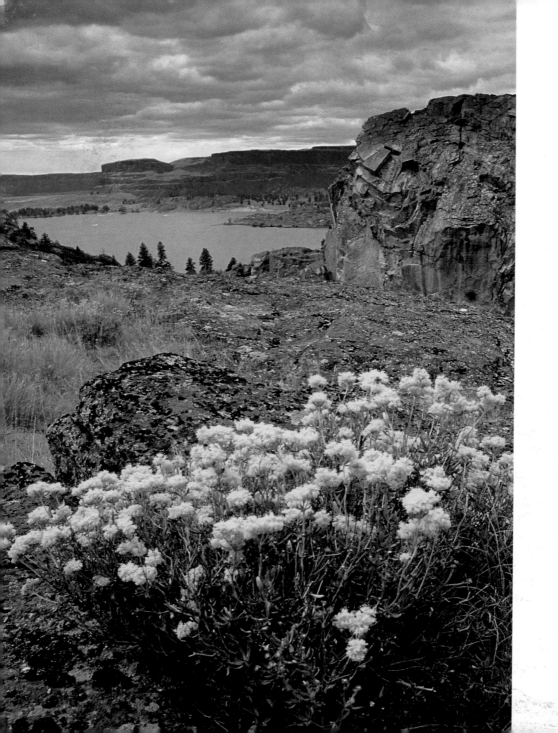

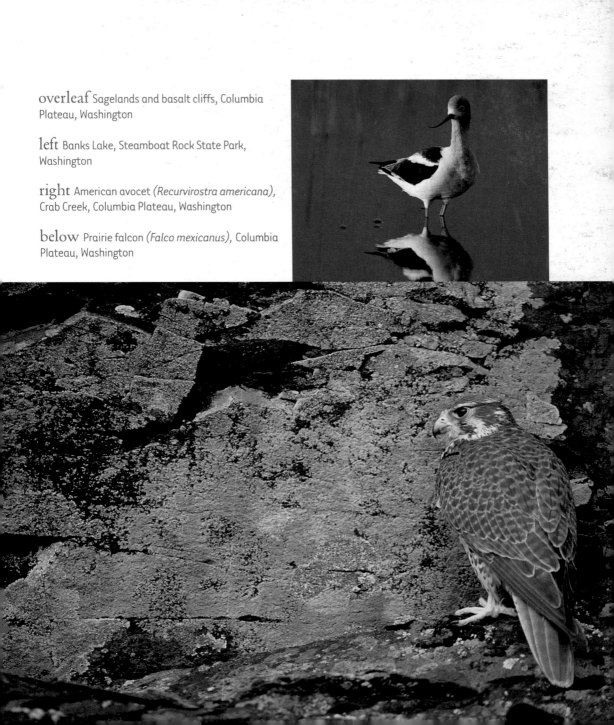

overleaf Sagelands and basalt cliffs, Columbia Plateau, Washington

left Banks Lake, Steamboat Rock State Park, Washington

right American avocet *(Recurvirostra americana)*, Crab Creek, Columbia Plateau, Washington

below Prairie falcon *(Falco mexicanus)*, Columbia Plateau, Washington

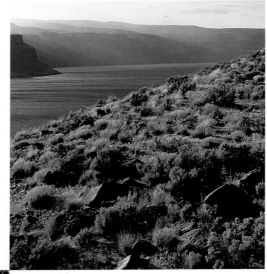

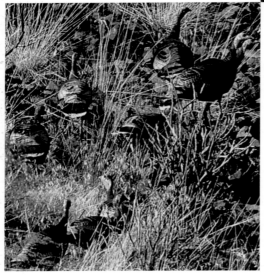

left Wild turkeys *(Meleagris gallopavo)*,
Hells Canyon National Recreation Area,
Oregon

above Columbia River, Columbia
Plateau, Washington

right Barn owl and owlets *(Tyto alba)*,
Columbia Plateau, Washington

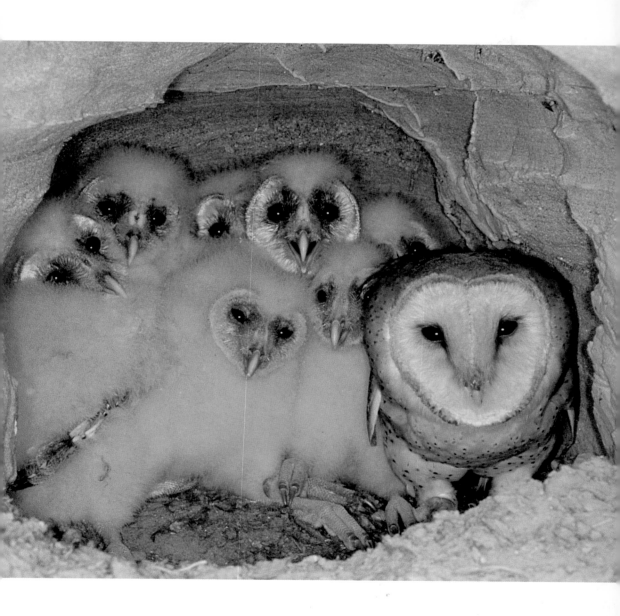

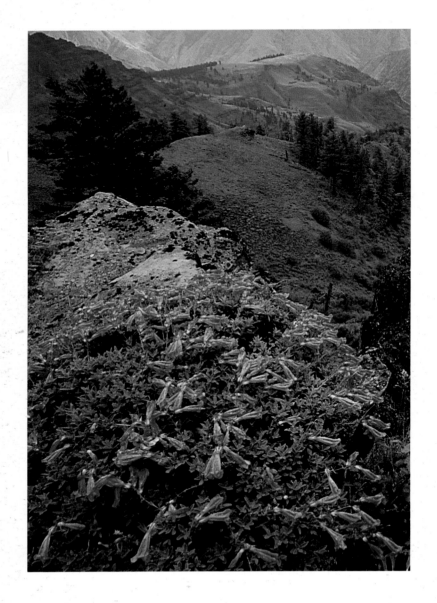

overleaf Ponderosa
pines *(Pinus pon-
derosa)*, Wallowa-
Whitman National
Forest, Idaho

left Cliff penstemon
(Penstemon rupicola),
Hells Canyon National
Recreation Area,
Oregon

right Wetland, Steens
Mountain, Oregon

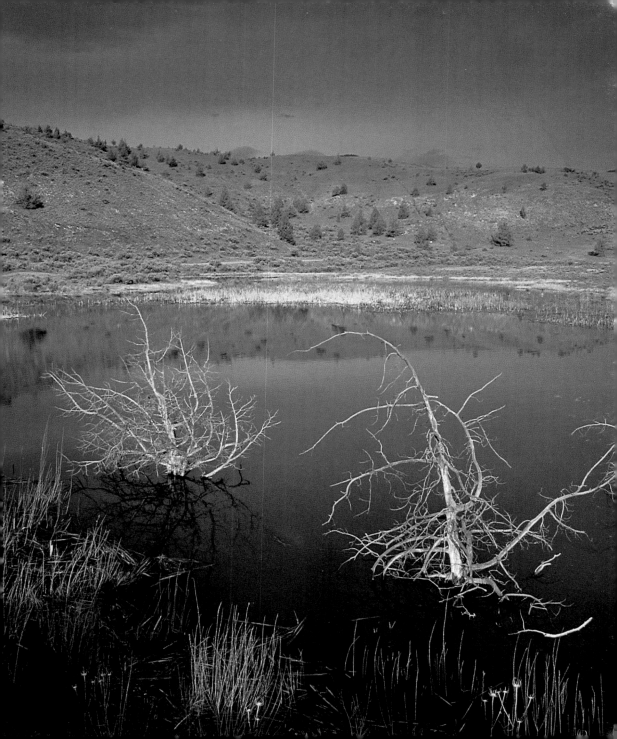

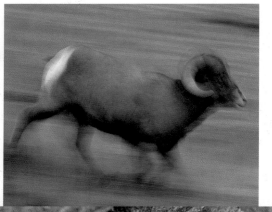

left Bighorn sheep *(Ovis canadensis)*, Hells Canyon National Recreation Area, Idaho

below Western rattlesnake *(Crotalus viridis)*, Columbia Plateau, Washington

right Basalt cliff, Steamboat Rock State Park, Washington

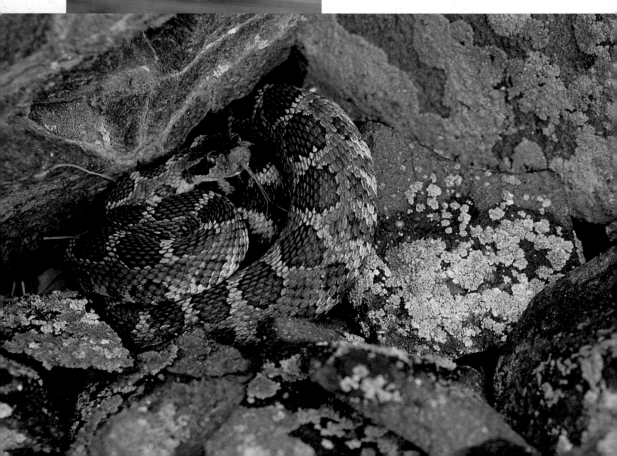

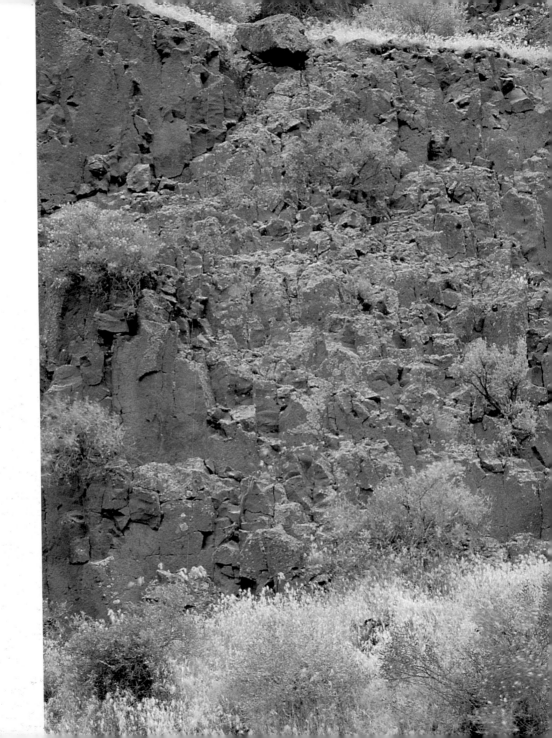

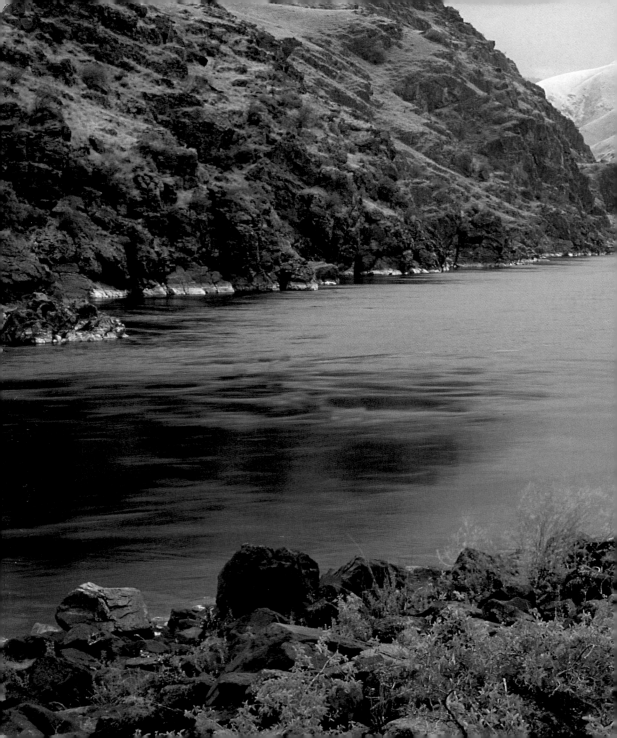

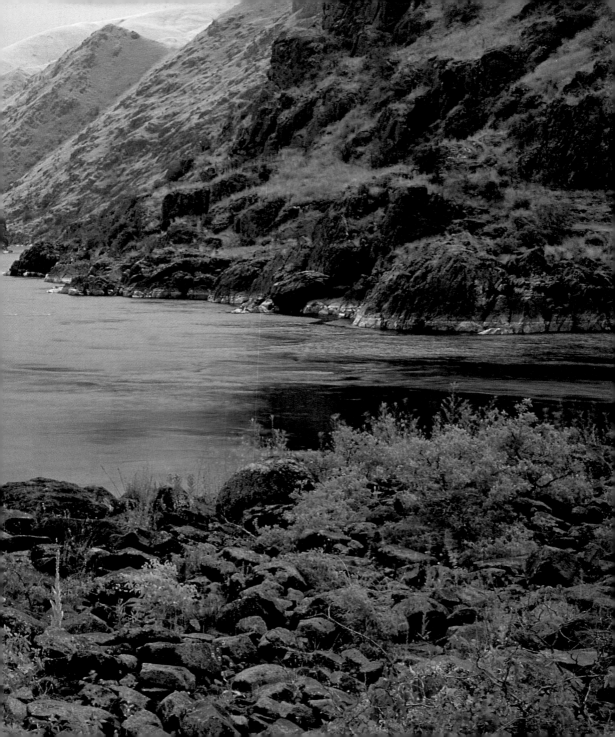

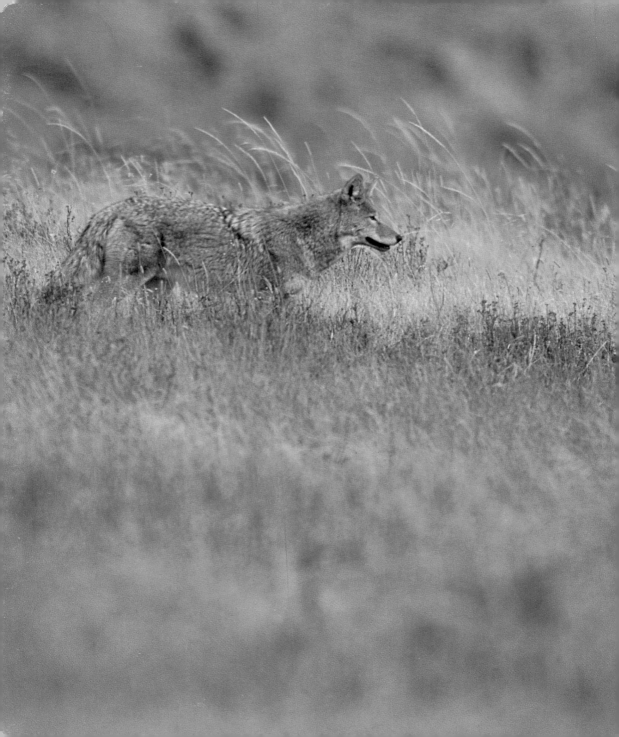

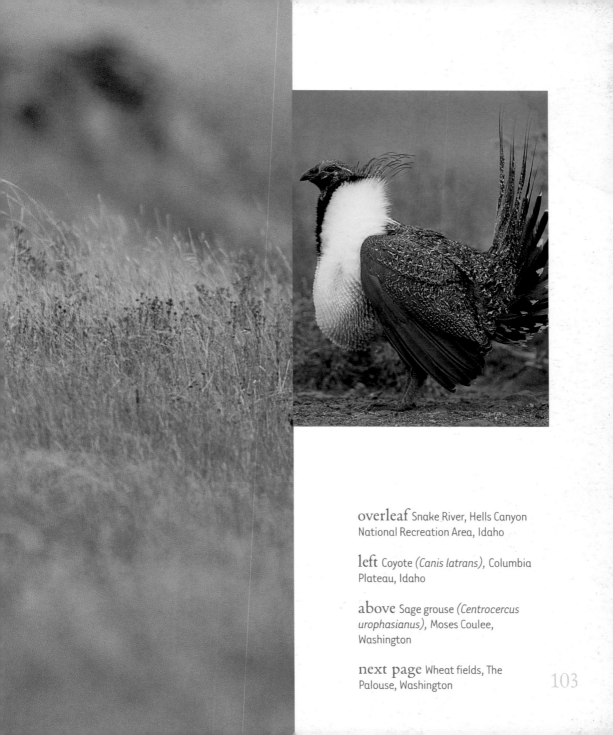

overleaf Snake River, Hells Canyon
National Recreation Area, Idaho

left Coyote *(Canis latrans)*, Columbia
Plateau, Idaho

above Sage grouse *(Centrocercus
urophasianus)*, Moses Coulee,
Washington

next page Wheat fields, The
Palouse, Washington

103

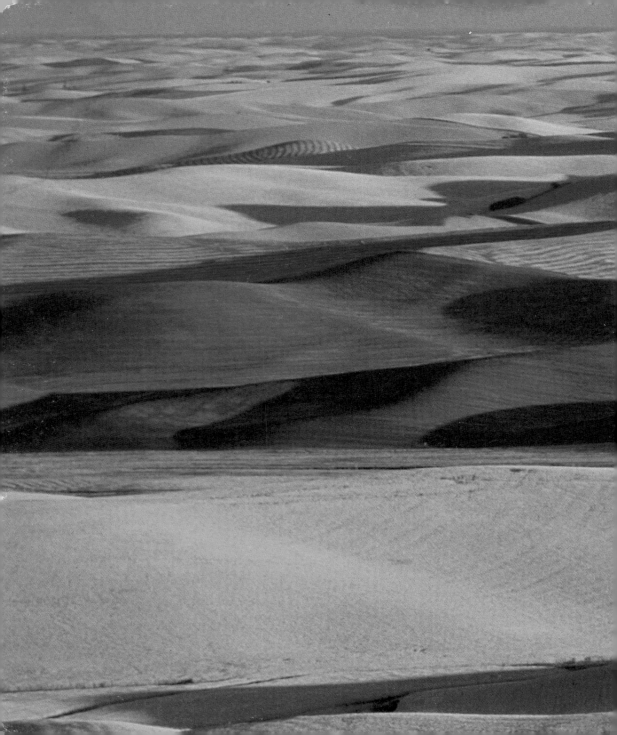

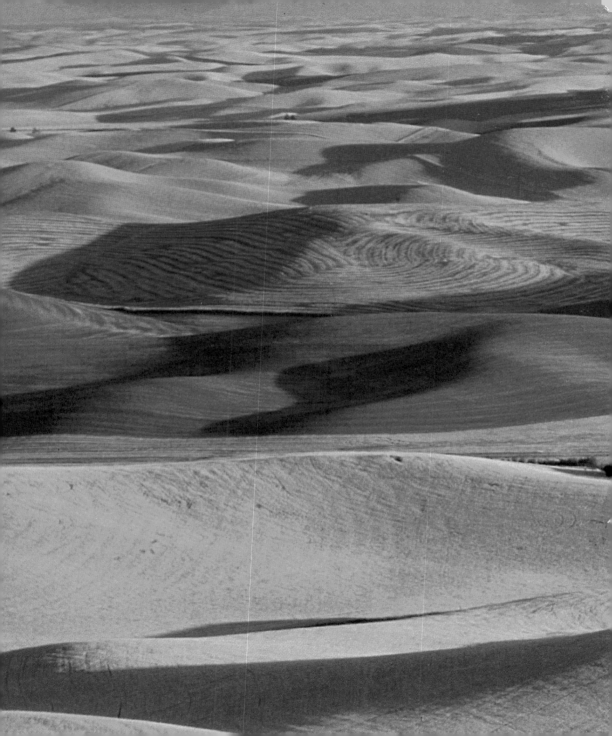

{ about the author }

Over the course of his 30-year career, Art Wolfe has worked on every continent and in hundreds of locations. His photographs are recognized throughout the world for their mastery of color, composition, and perspective. His unique approach to nature photography is based on his training in the arts and his love of the environment.

Wolfe has taken an estimated one million images in his lifetime and has released 57 books, including *The Living Wild*, which has sold more than 50,000 copies worldwide and garnered awards in *Applied Arts* and *Graphis*. His other books include *California*, *Alaska*, *Pacific Northwest*, and several children's books, such as *1, 2, 3 Moose* and *O is for Orca*.

Art Wolfe has been awarded the coveted Alfred Eisenstaedt Magazine Photography Award and has been named Outstanding Nature Photographer of the Year by the North American Nature Photography Association. The National Audubon Society recognized his work in support of the national wildlife refuge system with its first-ever Rachel Carson Award. Wolfe now spends nearly nine months a year traveling and shoots more than 2,000 rolls of film annually. He serves on the advisory boards for the Wildlife Conservation Society, Nature's Best Foundation, and the North American Nature Photographers Association, and frequently donates performances and work to dozens of environmental and educational groups.